Nathalie Prézeau

TORONTO
STREET
ART
STROLLS

A neighbourhood guide
to murals, graffiti & public art

Word
— of —
Mouth
Production

This book is dedicated to every street artist in Toronto.
"Colour is a power which directly influences the soul"
– Wassily Kandinsky

Published by Word-of-Mouth Production
299 Booth Avenue, Toronto, Ontario M4M 2M7, Canada
(416) 462-0670, torontofunplaces@gmail.com

Follow the author on:

facebook.com/TorontoUrbanStrolls
facebook.com/TorontoFunPlaces
instagram.com/torontourbanstrolls
pinterest.com/NathaliePrezeau
twitter.com/nathalieprezeau
www.torontofunplaces.com
www.torontourbanstrolls.com

Writing and photos: **Nathalie Prézeau**
Illustrations: **Johanne Pepin**
Proofreading: **Kerstin McCutcheon**
Honorary members of the author's exclusive Friends Whom I Exploit Shamelessly Club:
François Bergeron, Laurent Bergeron, Roxane Bergeron, Christian Castel, Monique Dobson, Claire Marier, Kerstin McCutcheon, Serge Paul, Martine Rheault, Julie Sabourin
Design and layout: **Publisher Friendly Inc.** (416) 333-9512
Printing: **Marquis Book Printing Inc.** (418) 246-5666

Library and Archives Canada Cataloguing in Publication

Prézeau, Nathalie, 1960 –, author
 Toronto street art strolls / Nathalie Prézeau.
Includes index.
ISBN 978-0-9684432-9-3 (softcover)

 1. Street art--Ontario--Toronto--Guidebooks.
 2. Street art--Ontario--Toronto--Pictorial works.
 3. Walking--Ontario--Toronto--Guidebooks.
 4. Toronto (Ont.)--Guidebooks. I. Title.

ND2643.T67P74 2017 751.7'309713541 C2017-900932-X

A word from the author

I'm passionate about urbanism and anything that improves a city's walkability. This is why I'm such a sucker for street art. It is the best and quickest way to add whimsy to our walks.

Urban fun at Church & Shuter with my girlfriends!

I once took an introverted 19-year-old and a sceptical retired baby boomer on two separate photo sessions in the same week. It seems this guide will appeal to a wide range of explorers!

Based on the number of pictures my young friend took and shared on the spot in the alleys of Harbord Village, our outing was a hit! As for the reluctant 66-year-old woman, whom I dragged kicking and fighting to admire rogue art under the 401, I lost her for thirty minutes as she went on her own photo shoot, caught by the beauty in the cool chaos.

When I walk alone, I get all philosophical. Life metaphors kept coming to me as I scouted the city for this book. Most of the time, I discovered beauty when I pushed a bit further. When I went off the obvious route, very often something cool happened, an adventure awaited just around the corner. Every time I looked more carefully, a little gem popped out. That's why I could not resist inserting little bits of "TAO of Street Art" in the guide. Only afterwards did I realize that TAO is a Chinese word for "path", "way", or "route". How appropriate for a walking guide!

I found out that locals often don't know about a gorgeous mural in their neighbourhood for the sole reason that it is slightly off their normal route.

I'm hoping this guide will give you the incentive to take the time to "stop and smell the roses", or more accurately, to stop and see the urban gems blossoming on the walls throughout our whimsical city.

Enjoy!

Nathalie Prézeau

Author, publisher, photographer
torontofunplaces@gmail.com

TORONTO STREET ART STROLLS MAP

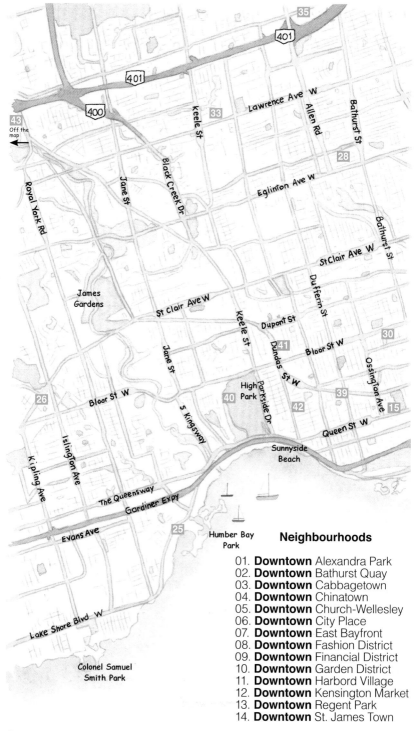

Neighbourhoods

01. **Downtown** Alexandra Park
02. **Downtown** Bathurst Quay
03. **Downtown** Cabbagetown
04. **Downtown** Chinatown
05. **Downtown** Church-Wellesley
06. **Downtown** City Place
07. **Downtown** East Bayfront
08. **Downtown** Fashion District
09. **Downtown** Financial District
10. **Downtown** Garden District
11. **Downtown** Harbord Village
12. **Downtown** Kensington Market
13. **Downtown** Regent Park
14. **Downtown** St. James Town

TORONTO URBAN STROLLS MAP

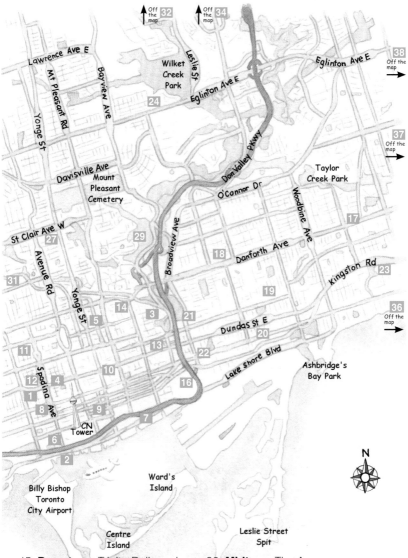

TORONTO SUBWAY STATIONS

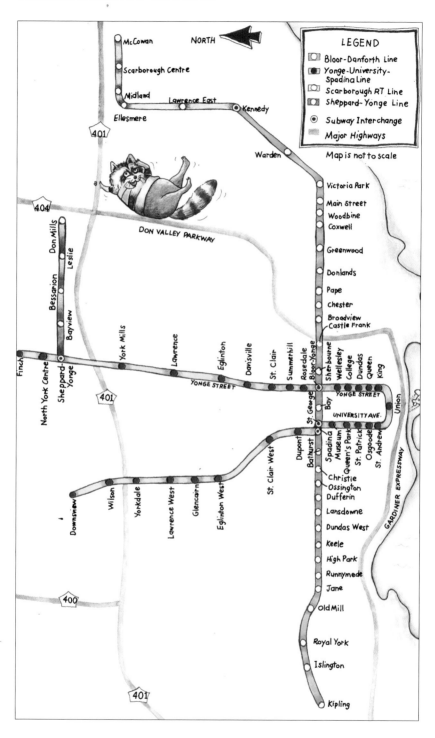

Strolls by subway station

Want to go carless? Here's a list of Toronto subway stations included in the strolls featured in this guide.

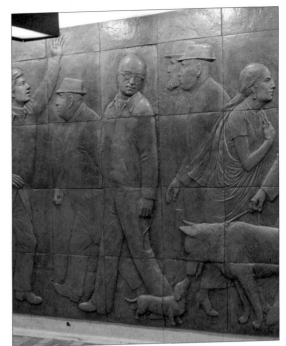

Spectacular *Cross Section* by **William McElcheran** (northwest entrance to Dundas Station).

TORONTO STREET ART STROLLS

ETOBICOKE

MIDTOWN

NORTH YORK

SCARBOROUGH

WEST END

YORK-CROSSTOWN

EVENTS

GETAWAYS

STROLL
1

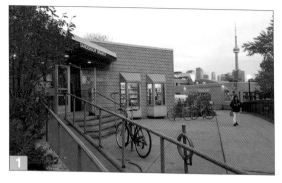

Neighbourhood
Alexandra Park
+ Trinity-Bellwoods

Suggested walk
2 km (30 min)

The lively skatepark in **Alexandra Park** is surrounded by great pieces. Large containers turned into canteens add to the cool factor. Lots of cafés, restaurants and art in the alleys around Dundas W.

TTC & Parking
• Streetcar **505** runs along Dundas.
• Free street parking W of Bathurst.

While you're here
• The big finish (bonfire) of the exciting **Kensington Market Winter Solstice** takes place in Alexandra Park on December 21.

1 Dundas W & Bathurst
2 Dundas W & Casimir
3 Dundas W & Casimir
4 Around **Scadding Court Community Centre**
(About **artists**, see p. 190)

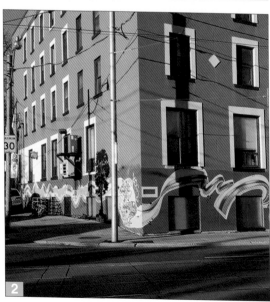

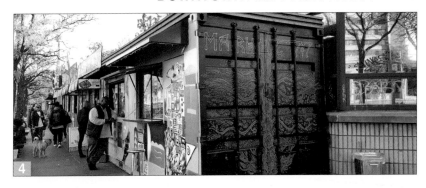

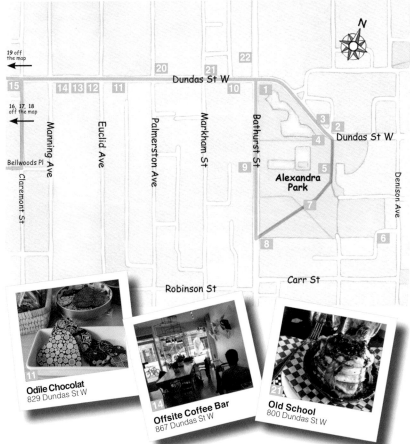

Odile Chocolat
829 Dundas St W

Offsite Coffee Bar
867 Dundas St W

Old School
800 Dundas St W

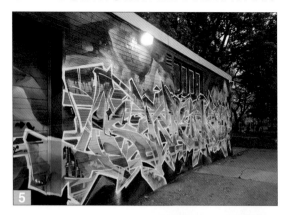

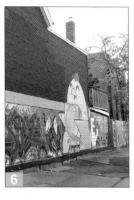

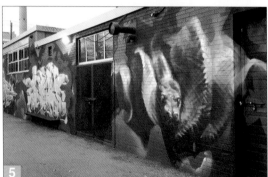

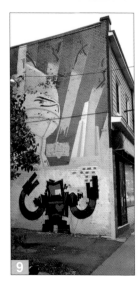

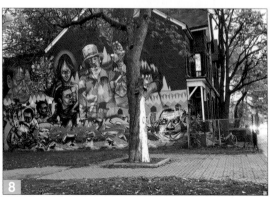

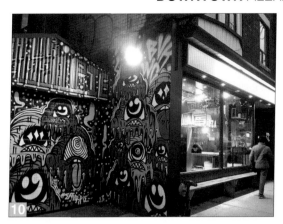

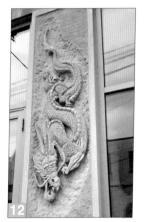

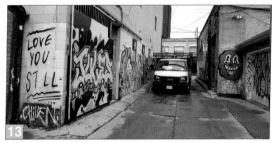

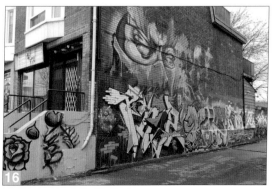

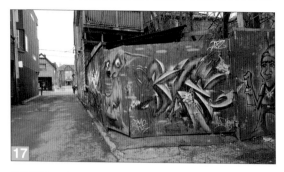

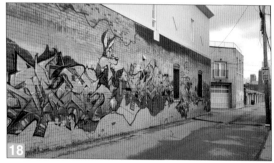

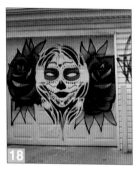

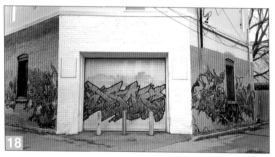

17 Lane E of 899 Dundas W
18 Lane N of Bellwoods Pl
 (off the map, west of
 Claremont)
19 E side of 904 Dundas W
20 W side of 768 Dundas W
21 **Old School**
22 N side of 358 Bathurst
(About **artists**, see p. 190)

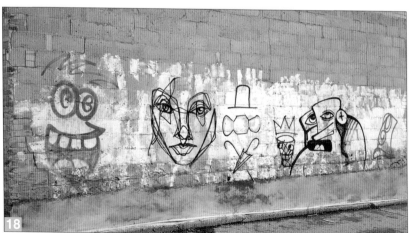

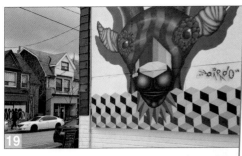

THE TAO OF STREET ART
Let's go as far as we can!

When there's street art on one side of a building, chances are the artist worked around the building as far as she could reach. A good example is the **Women's Residence** at 674 Dundas Street West, where a colourful ribbon gracefully wraps three sides of the building for homeless, single women of 16 years and over. The project was led by artist **Paula "Bomba" Gonzalez** with support from **StreetARToronto** and the **Scadding Court Community Centre**.

We never know what good thing awaits around the corner! It is worth pushing oneself a little bit further to find out.

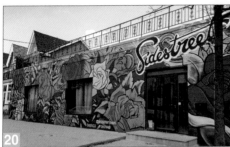

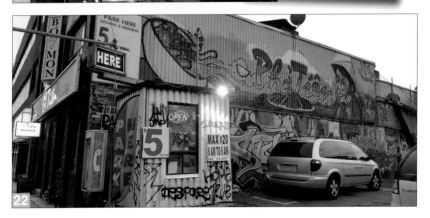

STROLL
2

Neighbourhood
Bathurst Quay

Suggested walk
4.2 km (1 hr)

This is one eclectic stroll filled with public art. Expect sculptural wave decks, yellow umbrellas, totem, giant lion, tribute to the Irish immigrants, embedded dragonflies and more.

TTC & Parking
• You can take streetcar **509 Harbourfront** inside Union Subway Station.
• Paid parking at Spadina Pier (at the foot of the Music Garden) is a bit cheaper.

While you're here
• You can rent self-guided audio tours of the **Toronto Music Garden** for $6 at the Marina Quay West office on the pier south of the garden.
• Two fun ways to explore the **Billy Bishop Airport Terminal**: take the shortest free ferry ride to cross the channel, or the pedestrian tunnel with moving walkways and one of Canada's longest escalator systems!

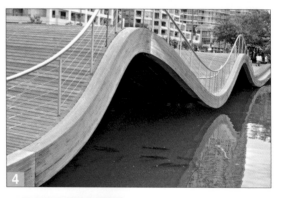

1 In front of **BeaverTails**
2 **Pearl Harbourfront**
3 **Harbourfront Centre** and **Lakeside Eats**
4 **Simcoe WaveDeck**
5 **PawsWay**
6 **Amsterdam BrewHouse**
7 **HTO Park**
(About **artists**, see p. 190)

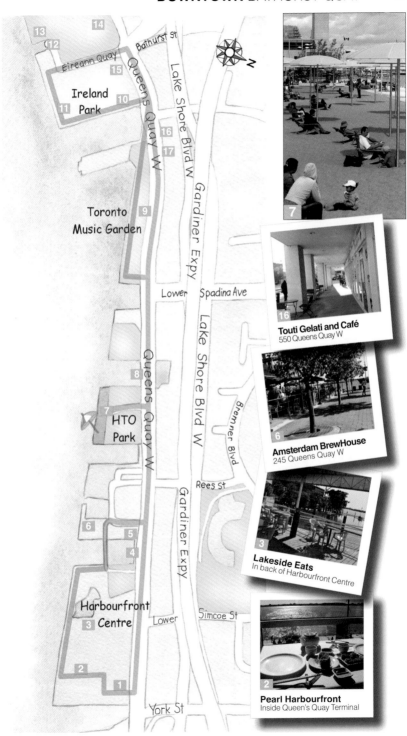

Bathurst St
Eireann Quay
Queens Quay W
Lake Shore Blvd W
Gardiner Expy

Ireland Park

Toronto Music Garden

Lower Spadina Ave

Lake Shore Blvd W

Bremner Blvd

Rees St

HTO Park

Queens Quay W

Harbourfront Centre

Lower Simcoe St

Gardiner Expy

York St

N

7

Touti Gelati and Café
550 Queens Quay W

Amsterdam BrewHouse
245 Queens Quay W

Lakeside Eats
In back of Harbourfront Centre

Pearl Harbourfront
Inside Queen's Quay Terminal

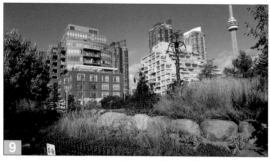

8 **Spadina WaveDeck**
9 **Toronto Music Garden**
10 East side of **Harbourfront Community Centre**
11 **Ireland Park**
12 **Billy Bishop Toronto City Airport Terminal**
13 Playground in **Little Norway Park**
14 **Little Norway Park**
15 **Harbourfront Community Centre**
16 **Touti Gelati and Café**
17 East of 550 Queens Quay W

(About **artists**, see p. 190)

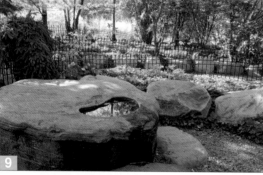

BENEATH THE LUXURIANT FOLIAGE
IN ITS GLASSY SURFACE
JOSEPH SOUCHETTE, 1831

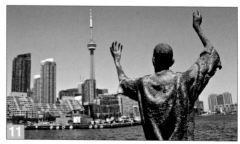

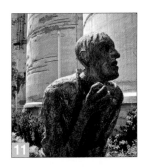

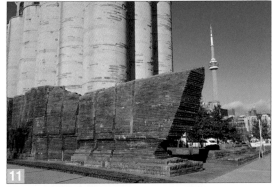

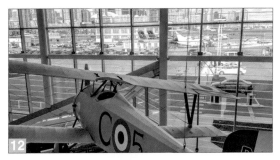

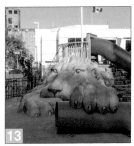

STROLL
3

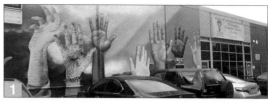

Neighbourhood
Cabbagetown

Suggested walk
5.6 km (1 hr 25 min)

Cabbagetown has a unique character with its labyrinth of secret lanes and small Victorian houses. Add to this good street art in the alleys E and W of Parliament.

TTC & Parking
• Streetcar **506** runs along Parliament and Carlton.
• You're allowed to park for free on most streets east of Parliament Street.

While you're here
• Shopping! The best gift shops are found within the triangle encompassing **Labour of Love** (223 Carlton St), **Spruce** (455 Parliament St) and **Kendall & Co.** (514 Parliament St).
• **Necropolis Cemetery**, located across from cute **Riverdale Farm**, is one of the oldest in Toronto. Its Section R is beautiful.
• **Wellesley Park** is a hidden gem off Amelia, with stairs to Rosedale Valley Rd.

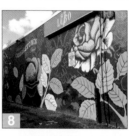

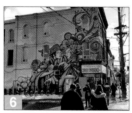

1 **Double Take Thrift Store**
2 Verner Lane
3 **House on Parliament**
4 Catbird Ln & Doctor O Ln
5 **The Scullery**
6 Parliament & Carlton
7 **Jet Fuel Coffee**
8 Side of **LCBO**
9 Broadcast Lane
10 Darling Lane
11 Jeffery's Lane
12 **Necropolis Cemetery**
13 Rawlings Ave & Carlton St
14 **Riverdale Park West**
15 Gordon Sinclair Lane
(About **artists**, see p. 190)

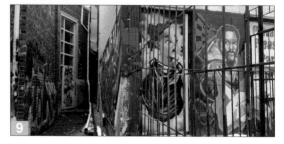

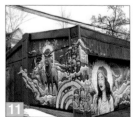

12

13

14

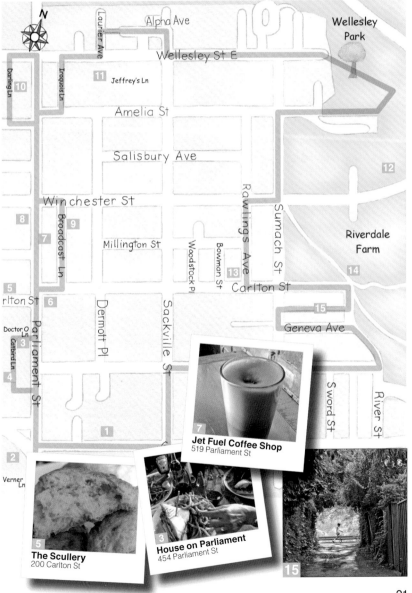

Alpha Ave

Wellesley Park

Laurier Ave

Wellesley St E

Darling Ln
10

Iroquois Ln

11 Jeffrey's Ln

Amelia St

Salisbury Ave

12

Winchester St

Rawlings Ave

Sumach St

8

Broadcast Ln

9

7

Millington St

Woodstock Pl

Bowman St

Riverdale Farm

13

14

5

rlton St

6

Carlton St

15

Dermott Pl

Sackville St

Geneva Ave

Doctor O Ln

3

Catbird Ln

4

Parliament St

Sword St

River St

7

Jet Fuel Coffee Shop
519 Parliament St

1

2

Verner Ln

5

The Scullery
200 Carlton St

3

House on Parliament
454 Parliament St

15

21

STROLL 4

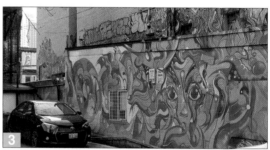

Neighbourhood
**Chinatown
+ Grange Park**

Suggested walk
2.4 km (35 min)

The walk first takes you around **OCAD** and ends at a cool part of Queen West. But at the heart of this stroll are the ambitious murals commissioned by the **Chinatown BIA,** east of the **AGO**. They are gorgeous and add to the visual stimuli of this busy part of Dundas West. North of Dundas, you'll find a cluster of rogue graffiti.

TTC & Parking
• **Osgoode Subway Station** is 200 m east of St. Patrick at Queen & University.
• There's a parking lot at 121 St Patrick St and some street parking nearby.

While you're here
• A good time to visit **Art Gallery of Ontario** (317 Dundas St W).
• **Scotiabank Theatre** (259 Richmond St W).
• **The Ballroom** (145 John St) is a beautiful upscale bowling place with good food and rooftop patio.

1 **The Rex** (jazz music)
2 **Malabar Limited**
3 Renfrew Place
4 Renfrew Pl & John St
5 **Umbra**
6 **Harrison Pool**
7 **Grange Park**
8 **OCAD**
(About **artists**, see p. 190)

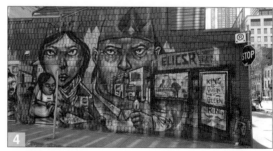

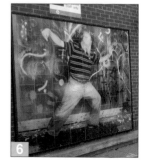

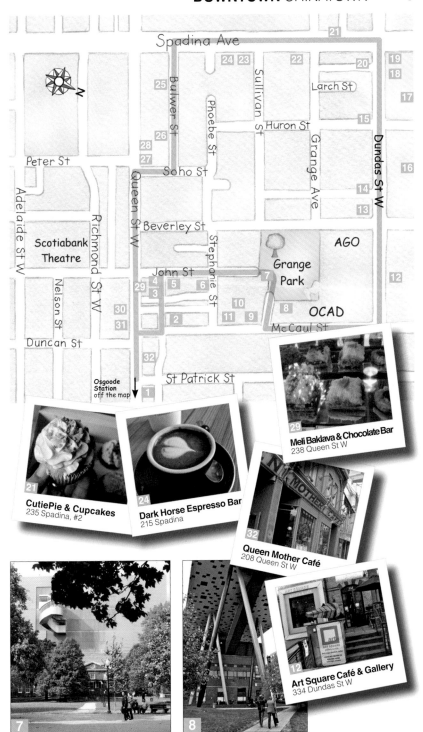

Spadina Ave

21

24 23 22 20 19 18

25 Larch St 17

Bulwer St

Phoebe St

Sullivan St

Huron St 15

26 Soho St

28
27

Peter St

Queen St W

Grange Ave

Dundas St W 16

Beverley St 14

13

Adelaide St W

Richmond St W

Scotiabank
Theatre

Stephanie St

Grange
Park

AGO

Nelson St

John St

29 4 5 6
3

7 12

10

11 9 8 OCAD

30

31 2 McCaul St

Duncan St

32

Osgoode
Station
off the map

St Patrick St

1

Meli Baklava & Chocolate Bar
238 Queen St W

CutiePie & Cupcakes
235 Spadina, #2

Dark Horse Espresso Bar
215 Spadina

Queen Mother Café
208 Queen St W

Art Square Café & Gallery
334 Dundas St W

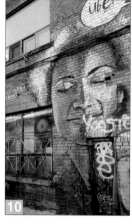

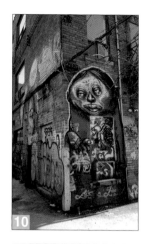

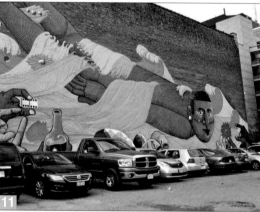
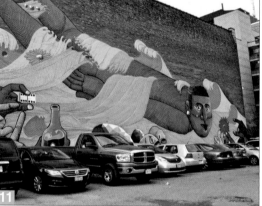

(About **artists**, see p. 190)

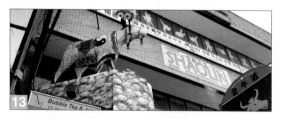

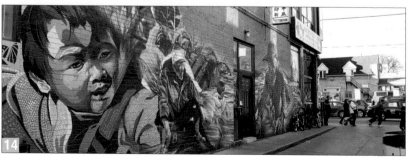

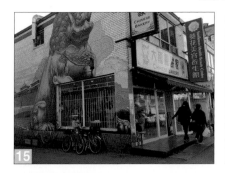

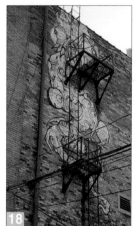

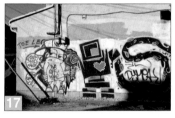

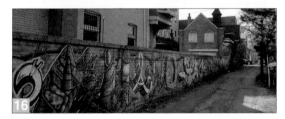

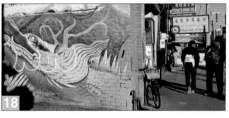

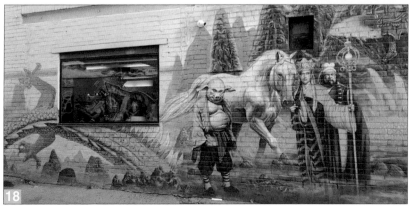

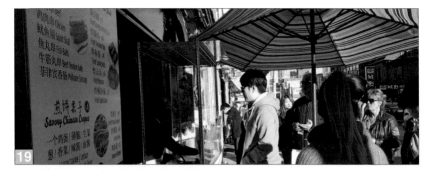

19 **Lamb Kebab-Savory Chinese Crepes**
20 Lane W of **CIBC**
21 Central lane on Spadina
22 **CutiePie & Cupcakes**
23 **Sonic Boom**
24 **Dark Horse Espresso Bar**
25 W side of 37 Bulwer St
26 Back of **Lululemon**
27 Queen W & Soho St
28 **Lululemon Athletica**
29 **Meli Baklava**
30 **CTV**
31 W side of 277 Queen W
32 **Queen Mother Café**
(About **artists**, see p. 190)

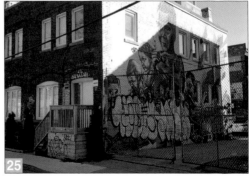

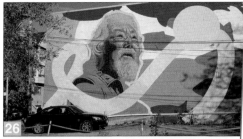

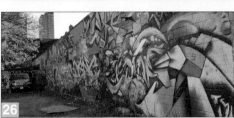

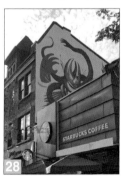

THE TAO OF STREET ART
We're here to leave our mark!

All graffiti artists develop a "tag" (a signature) but they obey a "street code" which makes it OK to paint over tags. The "bubbles" (inflated letters) can be drawn over tags. The "pieces" (elaborate words hard to read by the uninitiated) can go over bubbles and tags. And murals can go over all. Which is a major incentive for building owners to commission art on their empty walls! Those who dare go over existing artwork with inferior work risk seeing hours of work ruined by tags from the graffiti community, as a collective retribution. Some graffiti artists still choose to tag over murals in protest against what they consider an appropriation of what used to be an act of rebellion. Other street artists see nothing wrong with finding commissions to continue expressing themselves while trying to make a living from their art.

It's our job to find unique ways to express ourselves in this life.

STROLL
5

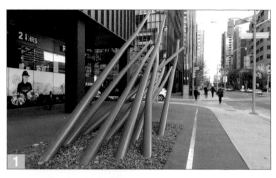

Neighbourhood
Church-Wellesley Village

Suggested walk
5 km (1 hr 15)

This walk first tours public art, then goes down Church to admire the **Church Street Mural Project**, marking Toronto's hosting of WorldPride 2014. Don't miss the pièce de resistance *Bathhouse Raids* by artist **Christiano De Araujo** south of College! On your way back, explore a line-up of cute parkettes.

TTC & Parking
• Exit at **Bloor-Yonge** or **College Stations**.
• **Green P** parking at 13 Isabella St E.

While you're here
• Affordable **Carlton Cinema** (20 Carlton St) is on this stroll, and so are the venues **Buddies in Bad Times** (12 Alexander) and **Panasonic Theatre** (651 Yonge).
• **Rosedale Valley Road** (top of map) is glorious in the fall! It takes you in 30 min to Cabbagetown (up the stairs at Bayview Ave).

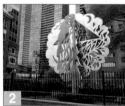

1 In front of **Rooster Coffee**
2 Stairs to the murals just N of this parkette
3 Art by **Ian Leventhal**
4 In front of **Rogers**
(About **artists**, see p. 190)

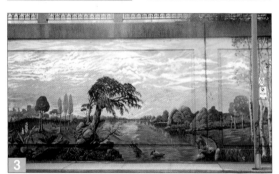

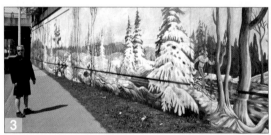

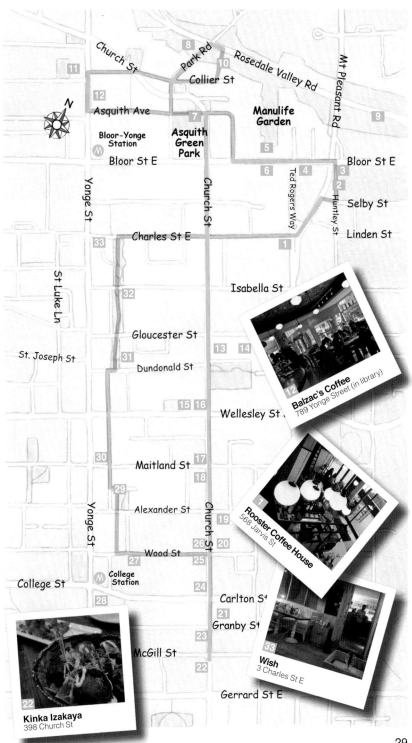

Church St

Park Rd

Rosedale Valley Rd

Mt Pleasant Rd

Collier St

Asquith Ave

Manulife Garden

Bloor-Yonge Station

Asquith Green Park

Bloor St E

Bloor St E

Yonge St

Church St

Ted Rogers Way

Huntley St

Selby St

Linden St

Charles St E

St Luke Ln

Isabella St

St. Joseph St

Gloucester St

Dundonald St

Wellesley St

Maitland St

Yonge St

Alexander St

Church St

Wood St

College Station

College St

Carlton St

Granby St

McGill St

Gerrard St E

Balzac's Coffee
789 Yonge Street (in library)

Rooster Coffee House
568 Jarvis St

Wish
3 Charles St E

Kinka Izakaya
398 Church St

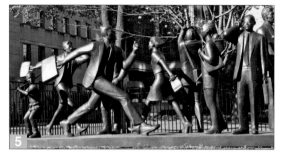

5 *Community* by **Kirk Newman**
6 Washrooms in **St. Paul's** at 227 Bloor E
7 **Asquith Green Park**
8 Park Rd & Rosedale Valley Rd
9 Rosedale Valley Rd
10 Staircase to Collier
11 **Town Hall Square**
12 **Balzac's Coffee**
13 **Barbara Hall Park**
14 **Aids Memorial**
15 Lane at 66 Wellesley
16 Church & Wellesley
17 Church & Maitland
18 508 Church
19 **Church Street School**
20 Church & Wood
(About **artists**, see p. 190)

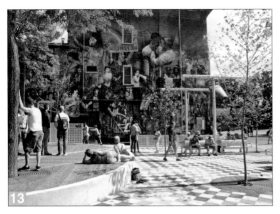

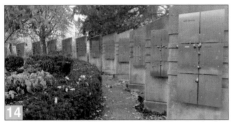

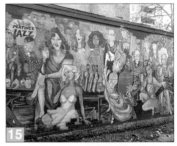

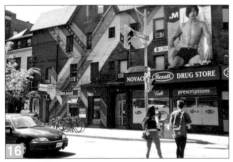

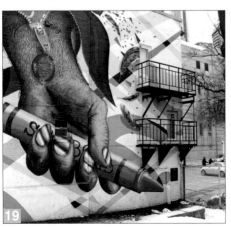

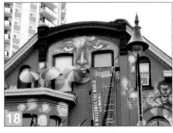

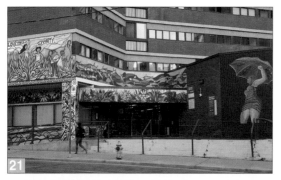

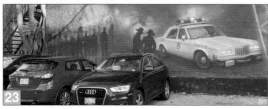

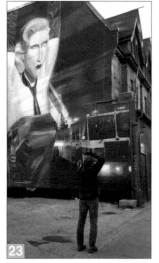

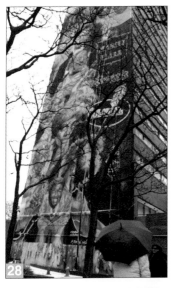

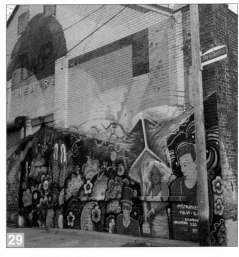

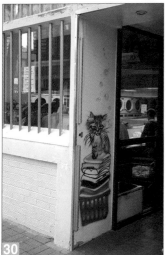

STROLL
6

Neighbourhood
**City Place +
Entertainment District**

Suggested walk
5.4 km (1 hr 20)

This stroll amidst over-towering condos includes some of the most interesting public art in the city, such as the bobbers by **Douglas Coupland** and *Barca Volante* by **Francisco Gazitua**.

TTC & Parking
• Exit at **Union Subway Station**.
• **Green P** at 10 Portland St.

While you're here
• The **Ripley's Aquarium** (next to the CN Tower) is fantastic!
• If you visit the **CN Tower**, have a bite with a view at affordable **Horizons** (one floor below the chic revolving restaurant).
• Try the **Skywalk** included in the circuit on the map. This stunning section of the **PATH** links **Union Station** to the **Metro Convention Centre**.
• **Fort York** is at its best during special events.

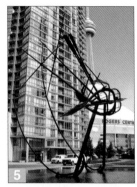

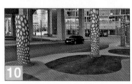

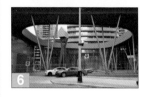

1 **Atlas Espresso Bar**
2 On Blue Jays Way
3 **Rogers Centre**
4 **Cora** (all-day breakfast)
5 *Barca Volante*
6 On Grand Trunk Ct
7 **Air Canada Centre**
 (also see S and E walls)
8 **Café 66**
9 **Canoe Landing Park**
10 N of Housey St
11 S of Housey St
12 **Canoe Landing Park**
13 Bathurst St & Fleet St
 (About **artists**, see p. 190)

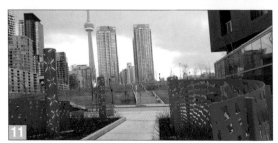

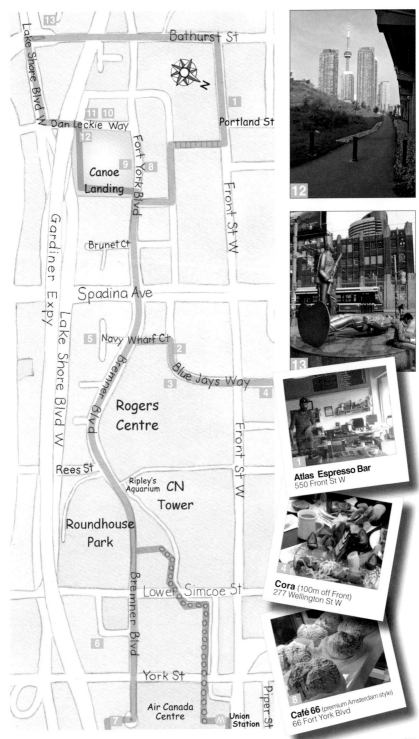

Lake Shore Blvd W

13

Bathurst St

Portland St

1

Dan Leckie Way

11 10

12

Fort York Blvd

Canoe Landing

9 8

Front St W

Brunet Ct

Gardiner Expy

Spadina Ave

Lake Shore Blvd W

Navy Wharf Ct

5

2

Bremner Blvd

Blue Jays Way

3

4

Rogers Centre

Front St W

Rees St

Ripley's Aquarium

CN Tower

Roundhouse Park

Bremner Blvd

Lower Simcoe St

6

York St

Air Canada Centre

Union Station

Piper St

7

12

13

Atlas Espresso Bar
550 Front St W

1

4

Cora (100m off Front)
277 Wellington St W

Café 66 (premium Amsterdam style)
66 Fort York Blvd

8

STROLL 7

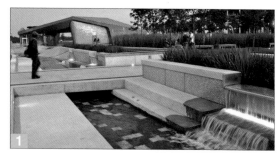

Neighbourhood
East Bayfront

Suggested walk
3.9 km (1 hr)

Waterfront Toronto has drastically transformed this neighbourhood in the last 10 years and will continue for years to improve waterfront walkability with special attention to esthetics.

TTC & Parking
• Bus **72** runs along Queens Quay.
• There are parking lots around **Sugar Beach**.
• **Loblaws'** customers who spend at least $10, can park for two hours.

While you're here
• You can't access the water from **Sugar Beach** but **Cherry Beach** is only a 5-min drive away (going eastbound on Lake Shore Blvd E and turning south on Cherry St).
• Catch the ferry at the foot of Bay St to **Ward's Island** to visit **Toronto Islands**, the unique carless residential section and grab a drink or a bite at the **Island Café** or the **Rectory Café**.

1 **Sherbourne Common**
2 **Sherbourne Common**
3 **George Brown College**
4 **Against the Grain**
5 **Corus Entertainment**
6 **Sugar Beach**
7 **Loblaws**
8 **Redpath**
9 Start of Yonge Street
10 Yonge & Queens Quay E
11 **Harbour Square Park**
12 **Harbour Square Park**
13 **Banksy** inside **One York** in **PATH** connection
(About **artists**, see p. 190)

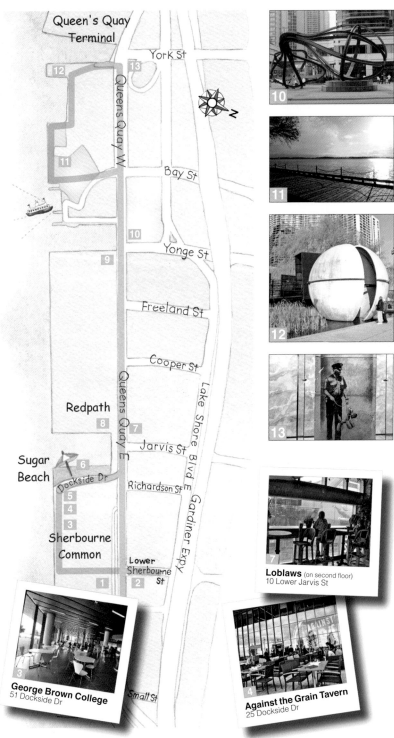

Queen's Quay Terminal

York St

Queens Quay W

N

Bay St

Yonge St

Freeland St

Cooper St

Redpath

Jarvis St

Sugar Beach

Dockside Dr

Richardson St

Sherbourne Common

Lake Shore Blvd

Gardiner Expy

Lower Sherbourne St

Small St

Loblaws (on second floor)
10 Lower Jarvis St

George Brown College
51 Dockside Dr

Against the Grain Tavern
25 Dockside Dr

STROLL
8

Neighbourhood
Fashion District

Suggested walk
2.4 km (35 min)

Rush Lane (between Augusta and Portland) is the most vibrant section of Toronto's favourite graffiti alley, which runs over 1.2 km from Spadina to Niagara Street (with a small detour on Richmond St at Portland).

TTC & Parking
• Streetcar **501** runs along Queen St.
• Affordable parking spaces on Denison, N of Queen.

While you're here
• Those into sewing will enjoy a cluster of fabric, bead and accessory shops between Augusta and Spadina. Don't miss the gorgeous ribbon boutique **Mokuba** (575 Queen W) with **Wildhagen Hats** upstairs and **Original** (531 Queen W), filled with evening gowns.
• **401 Richmond** (it's the name & address) is a culture hub including cafés, art galleries, the **Musideum** and the exciting **Spacing Store**.

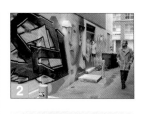

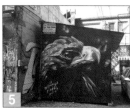

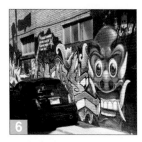

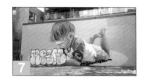

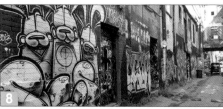

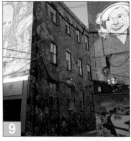

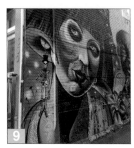

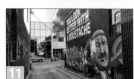

1 **Homebase** (street art supplies & merchandise)
2 Lane W of **The Chickery**
3 **The Ind_pendent**
4 **Millie Patisserie**
5 Lane W of Spadina Ave
6 W side of **Cacao 70**
7 457 Richmond St W
8 Lane E of Augusta Ave
9 E side of 530 Richmond W
10 Lane E of Portland
11 Lane E of 588 Richmond W
12 Lane E of Tecumseh
13 Lane E of Niagara St
14 Queen & Claremont St
15 Lane W of Augusta Ave
16 Lane E of Cameron St
17 **The Cameron House**
(About **artists**, see p. 190)

DOWNTOWN FASHION DISTRICT 8

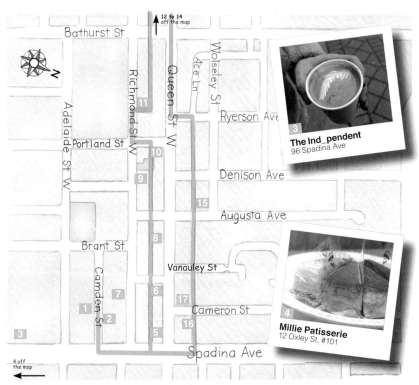

The Ind_pendent
96 Spadina Ave

Millie Patisserie
12 Oxley St, #101

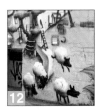

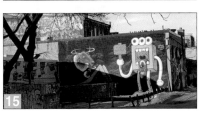

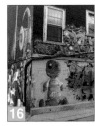

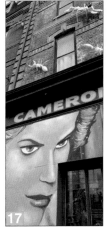

STROLL
9

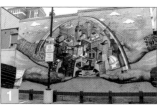

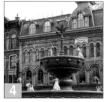

Neighbourhood
**Financial District
+ St. Lawrence**

Suggested walk
4.6 km (1 hr 10 min)

This stroll is all about
what you discover
when you hop from
one courtyard to the
next and look down
near skyscrapers.
There's too much
public art to see along
the circuit! Only the
ones easy to miss are
shown here.

TTC & Parking
• Exit at **King**, **Union**
or **St. Andrews Sub-
way Stations**.
• Try to park at **Green P
219** at 87 Richmond St,
off the map (best mural!).

While you're here
• Check the beautiful
ceiling of **Ben McNal-
ly Books** (366 Bay St,
S of Richmond).
• See the mural of nails
and a large model of
the city inside **City Hall**
(100 Queen St W).
• If the gate is open,
you must see the fan-
tastic patio of **Royal
Bank Plaza** up the
stairs by the colour-
ful characters on the
RBC wall facing Union
Station.

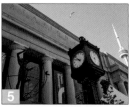

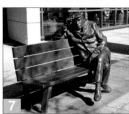

1 Art by **Spud**
(87 Richmond E,
off the map)
2 **Harlem Restaurant**
3 Art by **Banksy**
(back building)
4 **Berczy Park**
5 **Union Station**
6 **Second Cup**
7 **CBC** at 250 Front St W
8 **Ritz-Carlton**
9 **Shangri-La Hotel**
10 **Maman**
11 **Toronto-Dominion**
12 **Commerce Court**
13 **CIBC Private Wealth**
14 **Cloud Gardens**
15 **Dineen Coffee**
16 **Metropolitan**
17 Side of **Hi-Toronto Hostel**

(About **artists**, see p. 190)

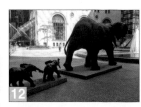

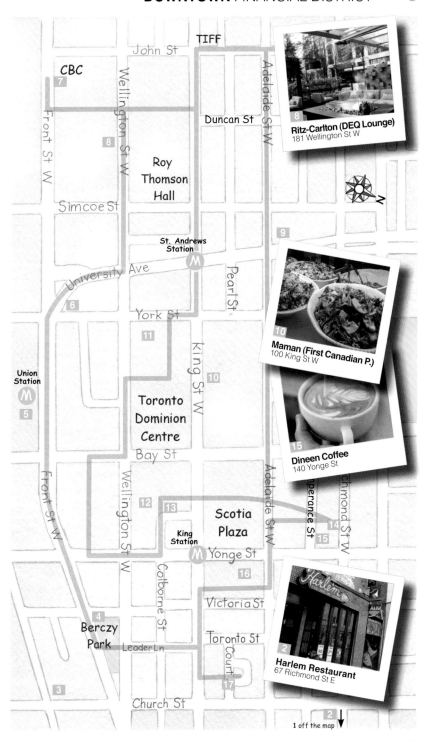

Ritz-Carlton (DEQ Lounge)
181 Wellington St W

Maman (First Canadian P.)
100 King St W

Dineen Coffee
140 Yonge St

Harlem Restaurant
67 Richmond St E

1 off the map

STROLL
10

Neighbourhood
Garden District

Suggested walk
4.1 km (1 hr)

There are many hidden gems here: fountains, pond, labyrinth, public art, **Ryerson University**'s surprising architecture and some cool street art off Church. Add to this the effervescence of **Yonge-Dundas Square** and shopping at the **Eaton Centre** and **Saks Fifth Avenue** across the street.

TTC & Parking
• Exit at **Queen** or **Dundas Subway Stations**.
• The parking lot on Victoria St, just north of Dundas, is the least expensive in the area.

While you're here
• For a list of events at **Yonge-Dundas Square**, see **www. ydsquare.ca**.
• Go to **www.music-mondays.ca** for the free shows in **Trinity Square**'s church.
• **Cineplex Yonge-Dundas** (10 Dundas E)
• **Nathan Phillips Square** & **City Hall** are just west of Bay St.

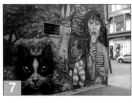

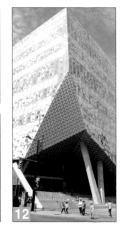

1 Devonian Square/Pond
2 Ryerson Image Arts
3 Alley E of pond
4 **Balzac's Coffee**
5 S side of 223 Church St
6 Church St & Shuter St
7 Lane W of **Massey Hall**
8 Back of **Church of the Holy Trinity**
9 **Trinity Square**
10 Eggspectation
11 Yonge-Dundas Square
12 Ryerson University
13 The Queen and Beaver
14 Jimmy's Coffee
15 Kerr Hall
(About **artists**, see p. 190)

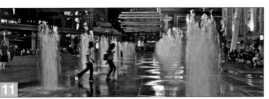

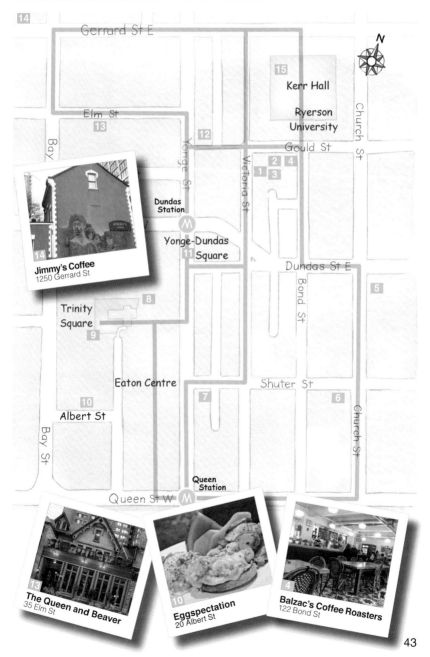

Jimmy's Coffee
1250 Gerrard St

The Queen and Beaver
35 Elm St

Eggspectation
20 Albert St

Balzac's Coffee Roasters
122 Bond St

STROLL
11

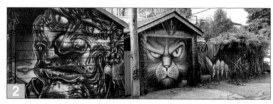

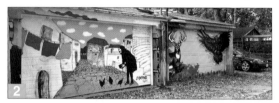

Neighbourhood
**Harbord Village +
Palmerston-Little Italy**

Suggested walk
8.9 km (2 hrs 15 min)

There are two sides of **Harbord Village**. There's the charming residential side of it, sandwiched between vibrant Harbord and College Streets. And there's the inner circuit of sheltered lanes, a fertile ground for graffiti, with some alleys featuring exciting clusters of uber cool street art.

TTC & Parking
• Streetcar **506** runs along College St.
• Free street parking along Grace (a good starting point for this stroll).

While you're here
• The **Royal Cinema** (608 College St) operates as a second-run indie/art house cinema. See their schedule at **www.theroyal.to**.
• **Bampot** (201 Harbord) is a cool tea & board games place filled with little nooks, serving vegetarian bites (no shoes allowed)!

1 **Bean & Baker
 Malt Shop**
1 Harbord & Jersey Ave
2 Lane W of
 Bickford Park
3 **Sam James Coffee Bar**
 and next door W of it
4 Lane E of 283 Harbord
(About **artists**, see p. 190)

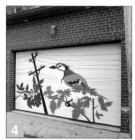

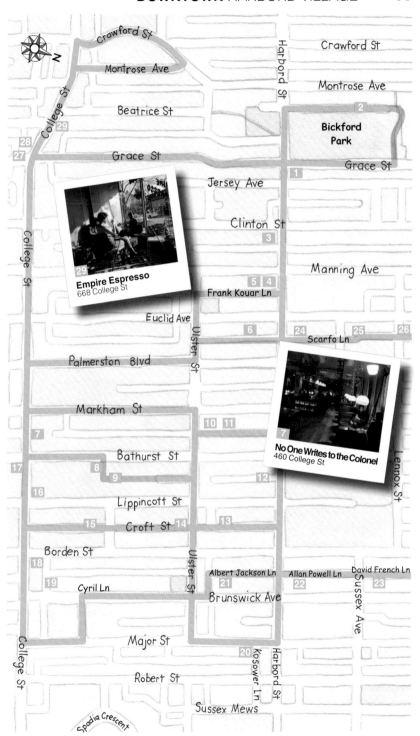

Empire Espresso
668 College St

No One Writes to the Colonel
460 College St

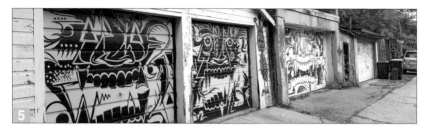

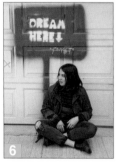

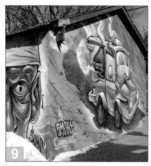

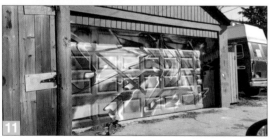

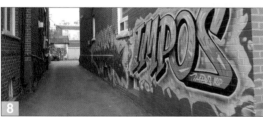

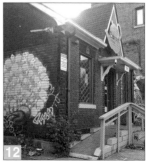

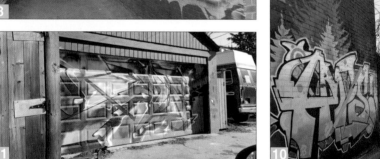

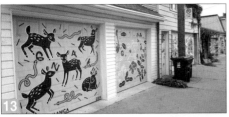

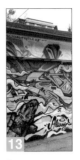

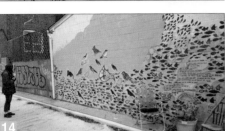

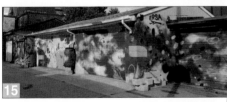

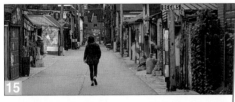

THE TAO OF STREET ART
We need to talk!

Croft Street features a unique series of 22 garage doors, a collective installation led by artists **Pascal Paquette** and **Sean Martindale**, with members of the **AGO Youth Council** and **StreetART** staff. The overall effect is one of harmony. I spoke with one of the residents involved and apparently, some officers of the Toronto Police agreed to go door to door to get approval from the residents. The artists agreed not to paint on the doors without permission. Most residents agreed to the overall project. That's a lot of people agreeing, don't you think? And we should be grateful for the outcome. This is quite a good model to emulate all over the city.

When people actually talk to each other, amazing things happen!

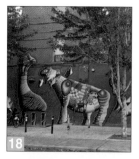

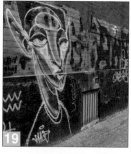

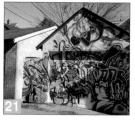

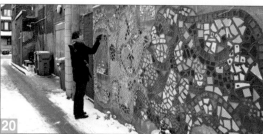

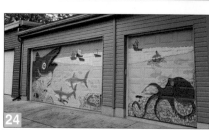

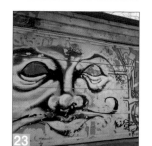

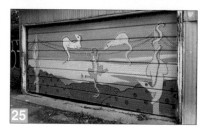

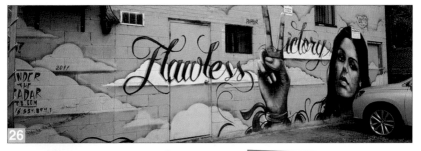

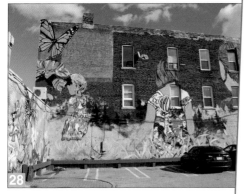

THE TAO OF STREET ART
Let's enjoy the present moment

I was first attracted by the splash of turquoise on a wall on **Croft Street** (which looks more like an alley than a street). As I got closer, I discovered a touching ode to a cat that inhabited this lane, written next to a painted school of fish. It thanked everyone who took a few moments of their time to stop and pet the beloved black cat. It lived in the present moment and didn't mind being used as an excuse for everyone to do the same, in the perfect setting of a quiet alley. By creating this lovely mural, the anonymous artist has continued the cat's legacy, anchoring us in the present moment.

We need to stop to smell the roses, pet the cat, or admire the art to recharge our batteries.

STROLL 12

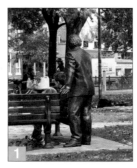

Neighbourhood
Kensington Market

Suggested walk
3 km (45 min)

There's a street art blanket covering the high-density neighbourhood. Every nook, lane and dead-end holds a surprise. The overall visual effervescence is compounded by the eclectic nature of the shops: a profusion of vintage stores, funky shops and ethnic markets.

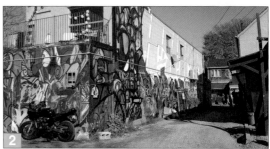

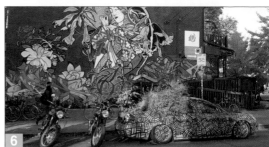

TTC & Parking
• Streetcar **506** runs along College St.
• There's a **Green P** east of Kensington Ave (access from Baldwin or St Andrews). Try to park on the roof level to enjoy a cool view of the city!

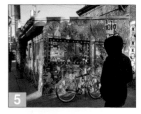

While you're here
• **Pedestrian Sundays** (last Sunday of every month from May to October, noon to 7 pm).
• Vintage finds to discover on Kensington Ave.
• You can pet cats at the **Tot the Cat Café** (298 College St).

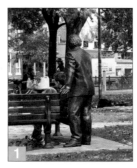

1	**Denison Square**
2	Lane N of 214 Augusta
3	**OM Grilled Cheese**
4	**Orbital Arts**
5	Augusta & Oxford St
6	Augusta & Oxford St
7	Lane W of Augusta

(About **artists**, see p. 190)

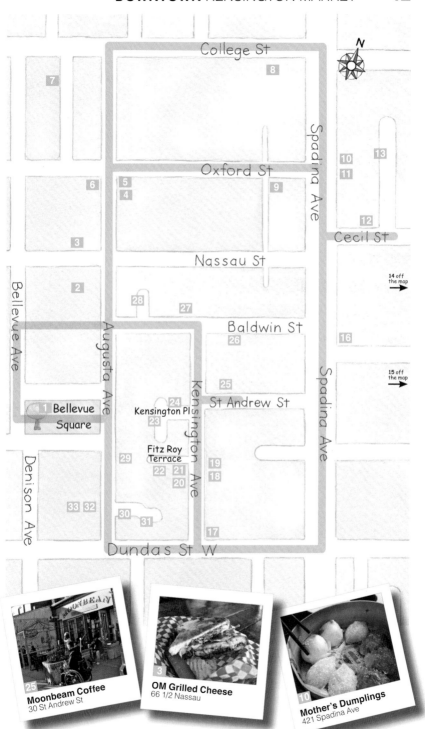

College St

8

7

Spadina Ave

Oxford St

10
13
11

6
5
4
9

Cecil St

3
12

Bellevue Ave

Nassau St

2

14 off the map →

28
27

Baldwin St

Augusta Ave

26
16

25
15 off the map →

1 Bellevue Square

24
Kensington Pl
23

St Andrew St

Spadina Ave

29

Fitz Roy Terrace

Denison Ave

22 21
20

19
18

33 32

30
31

17

Dundas St W

Moonbeam Coffee
30 St Andrew St

3 **OM Grilled Cheese**
66 1/2 Nassau

10 **Mother's Dumplings**
421 Spadina Ave

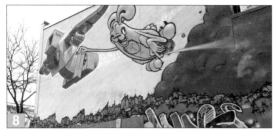

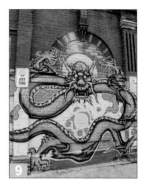

8 W side of 289 College St
9 Lane W of Spadina &
 S of Oxford
10 **Mother's Dumplings**
11 **Toronto Collective**
 (with art by **Bacon**)
12 **Sonic** (bike café)
13 Lane E of **Sonic**
14 125 Huron St (off the map)
15 107 Baldwin (off the map)
16 Spadina Ave & Baldwin
17 Dundas St W &
 Kensington Ave
18 Lane N of 33 Kensington
19 **Maison Close 1888**
20 **Courage my Love**
21 Fitzroy Terrace
22 Fitzroy Terrace
(About **artists**, see p. 190)

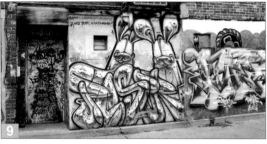

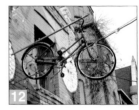

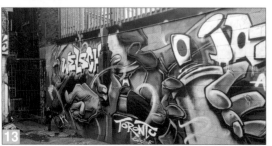

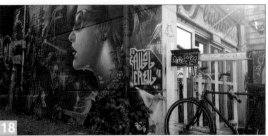

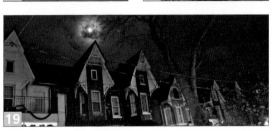

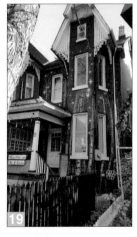

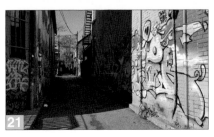

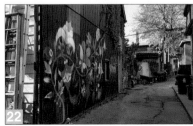

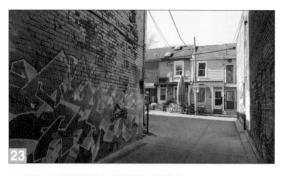

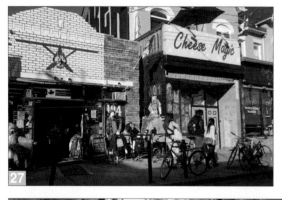

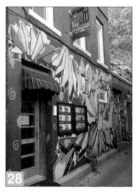

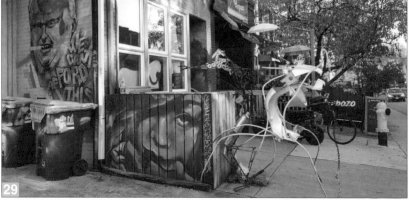

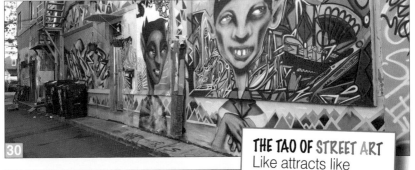

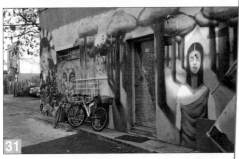

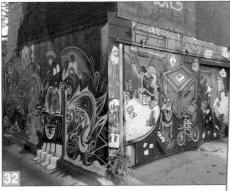

THE TAO OF STREET ART
Like attracts like

The best thing that can happen in a neighbourhood is when good artists leave their mark. The word spreads within the graffiti community and it attracts more talent, which means the street art spots mentioned in this guide will expand as long as there are walls to be covered. It also works with commissioned works. When I met artist **B.C. Johnson** as he was painting a business' garage door in the little lane north of Kingston Road (see p. 138), he told me he was asked by the neighbour to keep on painting on the adjacent door.

Every little step in the direction we want creates a momentum!

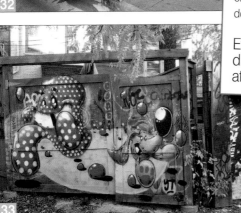

STROLL 13

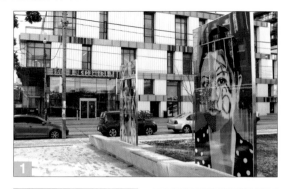

Neighbourhood
Regent Park

Suggested walk
2.1 km (30 min)

The paved plaza in revamped **Regent Park** features beautiful public art by artist **Dan Bergeron**, with light effects at night. (You can also see his Pan Am mural on p. 162.)

TTC & Parking
• Streetcar **505** runs along Dundas E.
• Paid parking max. $8 for 8 hrs at **Daniels Spectrum** (access via Sackville).

While you're here
• Check **www. danielsspectrum. ca** to find out about the shows in this cool venue (585 Dundas E).
• Access to state-of-the-art **Regent Park Aquatic Centre** is free (640 Dundas E). Find it on **www1. toronto.ca** for swim schedule.
• Did you know that Nelson Mandela attended the opening of **Nelson Mandela Park Public School**? Can you imagine the emotion?

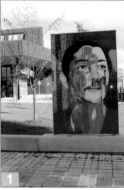

1. **Regent Park**
2. Greenhouse in the park
3. Dundas E & River St
4. **Daniels Spectrum**
5. Athletic grounds
6. Shuter & Sumach
7. **Sumach Espresso**
8. Sackville & Sutton
9. **Paintbox Bistro**
10. **Sultan of Samosas**
 (off the map)
(About **artists**, see p. 190)

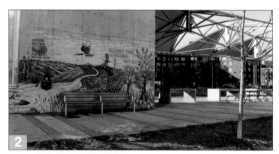

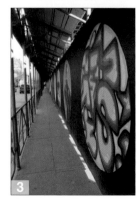

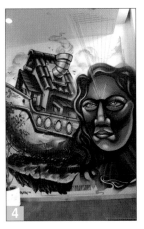

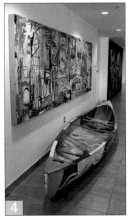

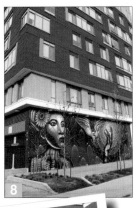

Map:

Gerrard St E

Sackville St

River St

10 off the map

Oak St

Regent Park Aquatic Centre

Cole St

Dundas St E

Daniels Spectrum

Sumach St

The Bruce Kidd Track

St David St

Sutton Ave

Nelson Mandela Park Public School

Shuter St

Wascana Ave

Sumach Espresso
118 Sumach St

Paintbox Bistro
555 Dundas St E

Sultan of Samosas
1 Oak St

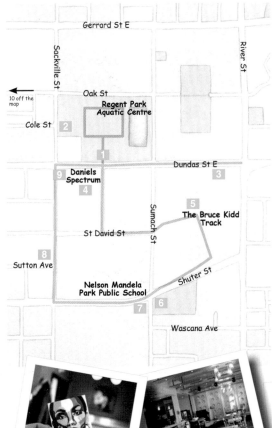

STROLL 14

Neighbourhood
St. James Town

Suggested walk
3.1 km (45 min)

Topped by high-brow Rosedale on the north and flanked by low-brow St. James Town on the east side, it is hard to find one word to describe the essence of this neighbourhood made of contrasts. You'll find street art east of Sherbourne (including Toronto's tallest mural) and superb public art west of it.

TTC & Parking
• Exit at **Sherbourne Subway Station**.
• There's a **Green P** at 405 Sherbourne St, north of Carlton.

While you're here
• **Allan Gardens** is open 365 days, from 10 am to 5 pm, free admission. You can enjoy four seasonal displays in the greenhouses during their Flower Shows.
• If you have the chance, enter **Mary of Lourdes Church** to admire its unique dome from the inside.

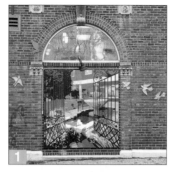

1 Trompe l'oeil facing park
2 Sherbourne & Wellesley
3 200 Wellesley St E
4 W side of 224 Wellesley
5 E side of 224 Wellesley
6 Back of **Food Basics**
(About **artists**, see p. 190)

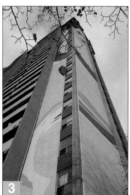

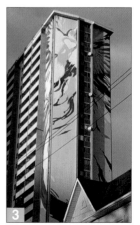

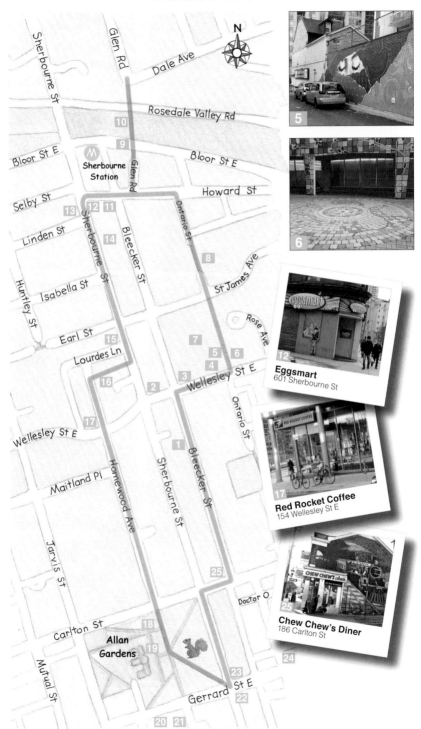

Eggsmart
601 Sherbourne St

Red Rocket Coffee
154 Wellesley St E

Chew Chew's Diner
186 Carlton St

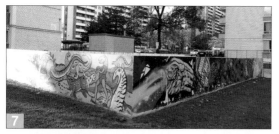

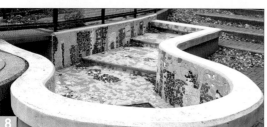

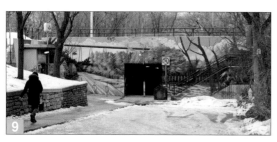

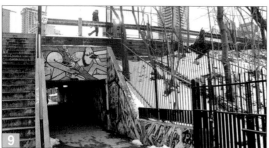

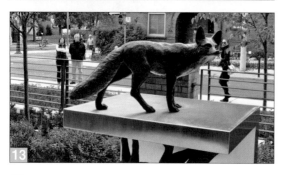

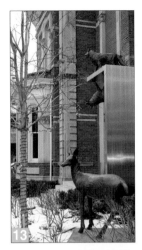

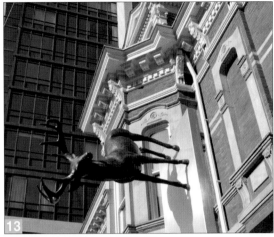

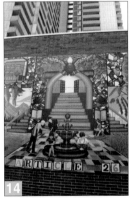

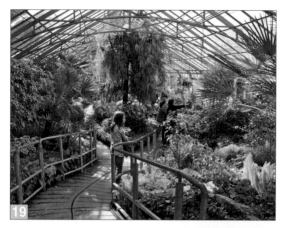

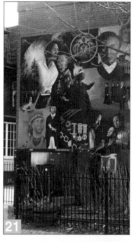

(About **artists**, see p. 190)

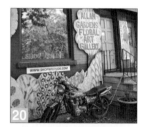

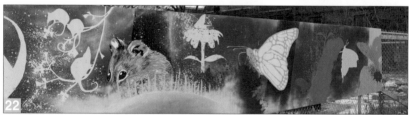

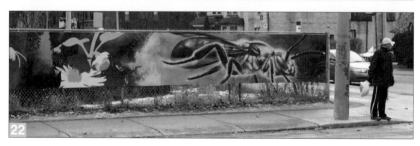

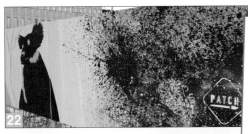

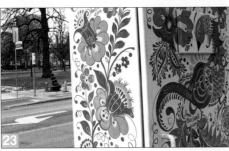

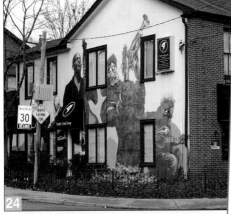

About the PATCH PROJECT

Have you noticed art popping up on the boards around construction sites all over Toronto?

In 2015, the City of Toronto enacted legislation that requires public artwork to be installed on new construction sites that encroach on the public realm. **The Patch Project** is a social enterprise operated by **The STEPS Initiative** (a Canada Revenue Agency registered charity) that provides end-to-end public art solutions to help its clients comply with the new requirements. They are helping private and public development groups to put together great hoarding art installations to make up for the temporary disturbance of any construction site. A great way to create community goodwill.

The *Artists* section on **www.thepatchproject.com** is a wonderful resource to meet the street artists responsible for a majority of the major art pieces in Toronto.

STROLL 15

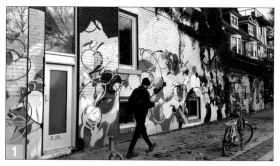

Neighbourhood
Trinity-Bellwoods + West Queen West

Suggested walk
5.4 km (1 hr 20 min)

Also called the **Art & Design District**, this neighbourhood includes very trendy **Drake Hotel**, very funky **Gladstone Hotel**, and many art galleries in addition to a lineup of restaurants, cafés, shops and bars along Queen, Ossington and Dundas. It also holds serious graffiti alleys!

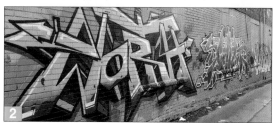

1 Dundas W & Crawford
2 Lane E of **A-1 Auto Service**
3 **Hawker Bar**
4 **Bellwoods Brewery**
5 **Bang Bang Ice Cream**
6 Lane N of Bruce St
(About **artists**, see p. 190)

TTC & Parking
• Streetcar **501** runs along Queen St.
• It is easier to find free street parking north of Dundas St.

While you're here
• Shopping! There are over 30 fashion stores in the five blocks between Bellwoods and Bathurst along Queen and interesting high-end vintage shops on Ossington.
• The **Gladstone** features 37 artist-designed rooms (check their scrapbook at the reception) and a lobby gallery on every floor.

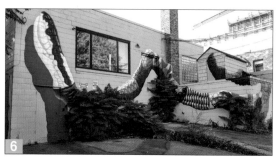

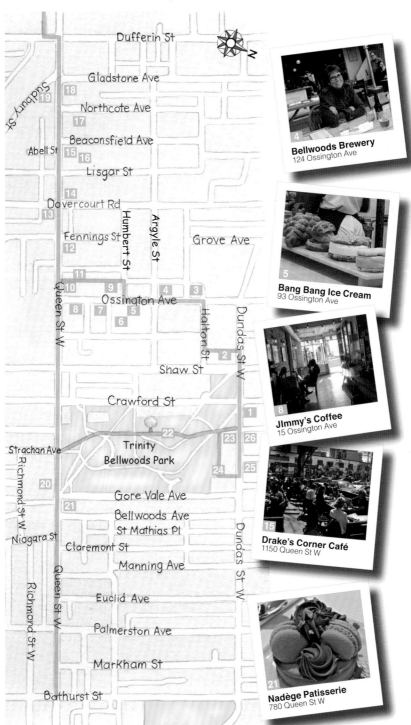

Dufferin St

Gladstone Ave

Sudbury St

19

18

Northcote Ave

17

Beaconsfield Ave

Abell St **15** **16**

Lisgar St

14

Dovercourt Rd

13

Fennings St

12

Humbert St

Argyle St

Grove Ave

11

10 **9**

Ossington Ave

4 **3**

8 **7**

5

6

Halton St

Dundas St W

Queen St W

2

Shaw St

Crawford St

22

23 **26**

Trinity
Bellwoods Park

24 **25**

Strachan Ave

Richmond St W

20

21

Gore Vale Ave

Bellwoods Ave

St Mathias Pl

Niagara St

Claremont St

Manning Ave

Dundas St W

1

Queen St W

Euclid Ave

Palmerston Ave

Richmond St W

Markham St

Bathurst St

4 Bellwoods Brewery
124 Ossington Ave

5 Bang Bang Ice Cream
93 Ossington Ave

8 Jimmy's Coffee
15 Ossington Ave

15 Drake's Corner Café
1150 Queen St W

21 Nadège Patisserie
780 Queen St W

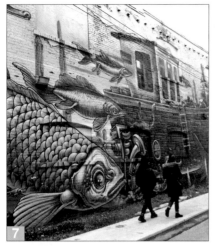

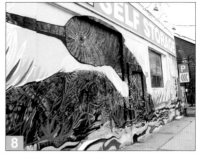

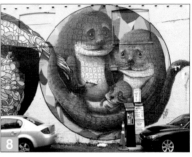

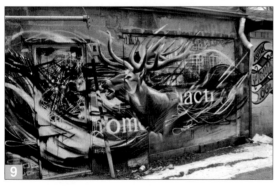

(About **artists**, see p. 190)

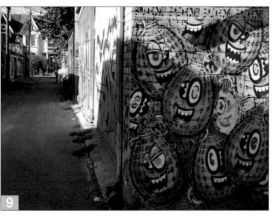

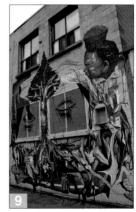

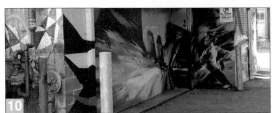

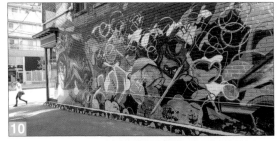

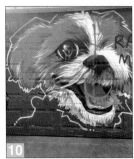

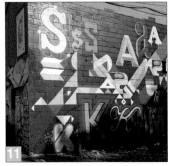

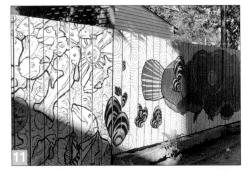

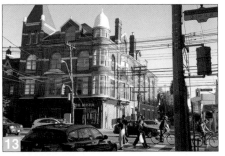

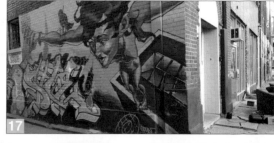

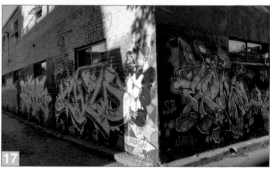

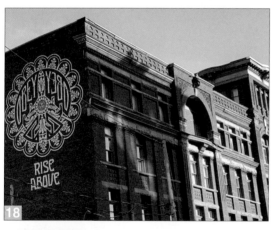

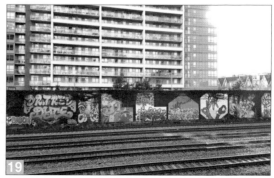

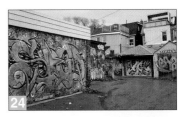

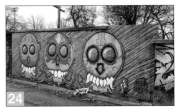

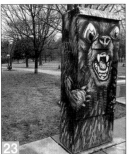

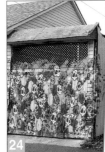

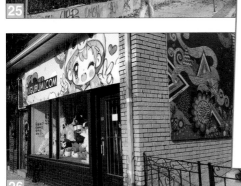

THE TAO OF STREET ART
Can't take things for granted!

I've returned to street art spots I had photographed years ago to take "before & after" shots and see how they have evolved. As I expected, most artwork got even better (many artists revisit their work to improve on it, remove tags, revive the colours, or apply a coat of varnish). But on a few occasions, I discovered that good murals were gone! The truth is, we never know what a new owner will decide to do with a beloved artwork. While it is true that today's grey wall could host next week's masterpiece, today's cool art could be tomorrows' bland wall.

Here today, maybe gone tomorrow.

STROLL 16

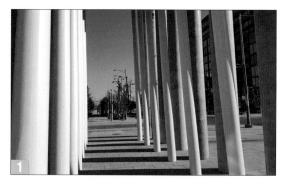

Neighbourhood
West Don Lands + Corktown

Suggested walk
3.8 km (1 hr)

This is a fantastic walk for both murals and public art, thanks to the sustainable development catalyzed by the **Toronto 2015 Pan Am/Parapan Games,** which left behind the **Cooper Koo Family YMCA**, a new section of Front Street, and a natural link between The Distillery and Riverside neighbourhoods.

TTC & Parking
• Streetcar **514** runs along Cherry St.
• If you don't find street parking, go to the paid parking lot of The Distillery (entrance on Parliament).

While you're here
• **The Distillery Historic District** is just across Cherry St.
• Women-only **Body Blitz Spa** with water circuit is at 497 King E by the murals. (Just saying...)

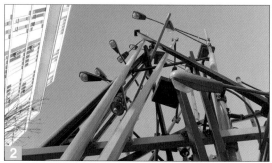

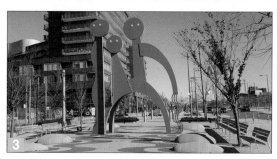

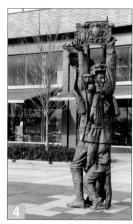

1 **Cooper Koo Family YMCA** and **Dark Horse Espresso Bar**
2 Front St Promenade
3 Front St Promenade
4 Front St Promenade and **Souk Tabule**
(About **artists**, see p. 190)

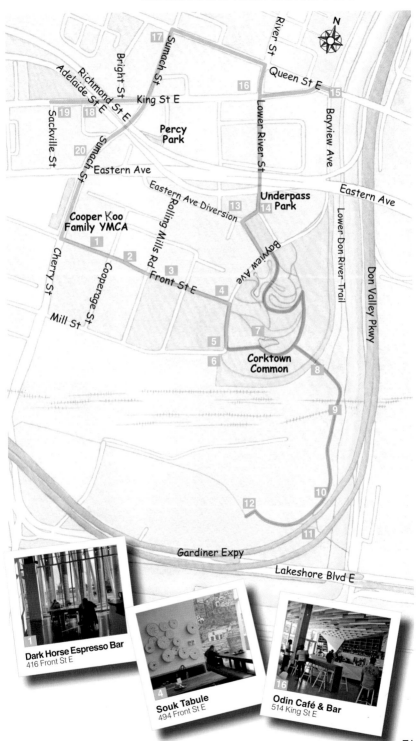

River St

N

Queen St E

Sumach St

Bright St

Richmond St E

Adelaide St E

King St E

17

16

15

Bayview Ave

19

18

Sackville St

20

Sumach St

Percy Park

Eastern Ave

Lower River St

Eastern Ave

Eastern Ave Diversion

Rolling Mills Rd

13

14

Underpass Park

Cooper Koo Family YMCA

Lower Don River Trail

1

2

3

4

Front St E

Bayview Ave

Cherry St

Cooperage St

Mill St

5

6

7

Corktown Common

8

Don Valley Pkwy

9

10

12

11

Gardiner Expy

Lakeshore Blvd E

1 Dark Horse Espresso Bar
416 Front St E

4 Souk Tabule
494 Front St E

16 Odin Café & Bar
514 King St E

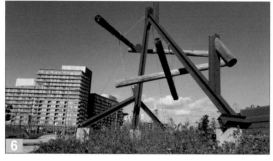

5 Mill St & Bayview Ave
6 Mill St & Bayview Ave
7 Splash pad in
 Corktown Common
8 Tunnel to **Lower Don**
 River Trail
9 **Lower Don River Trail**
10 **Lower Don River Trail**
11 **Lower Don River Trail**
12 **Lower Don River Trail**
(About **artists**, see p. 190)

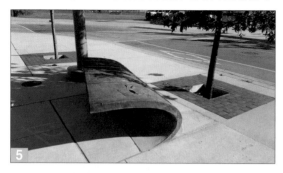

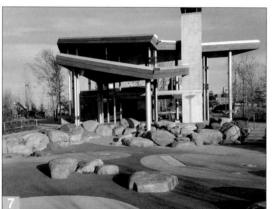

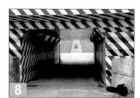

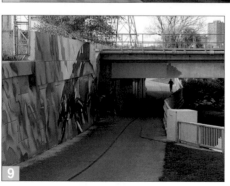

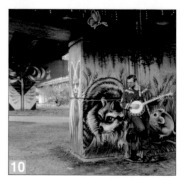

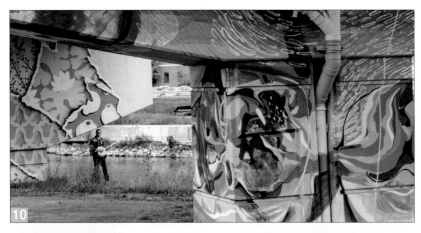

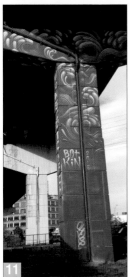

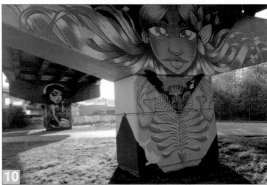

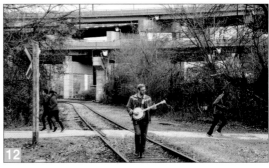

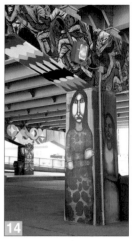

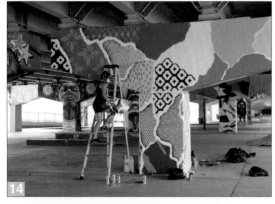

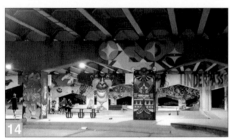

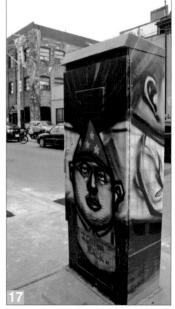

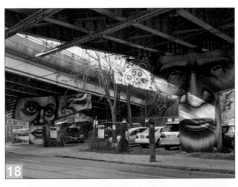

About the PAN AM PATH
Combining the power of art and sport.

The **Pan Am Path** is a multi-use trail which should, by the end of 2017, connect Toronto communities over 80-plus kms, from Claireville Reservoir to Highland Creek. It is a legacy of Toronto 2015 Pan Am Games which was initiated by a group of Toronto artists and city-builders, and endorsed by the Toronto City Council in 2013, followed eventually by the three levels of Government. **Art Relay** is the mural program with an ambitious goal of painting over 40 structures, bridges and underpasses along the trail. We're not there yet, but the artwork shown in this stroll along the **Lower Don River Trail** and in the **Underpass Park** are fantastic examples of what can be done. (Also see **Stroll 43** on p. 162.)

The *Trails* section on **www.panampath. org** offers a Google map of the full trail.

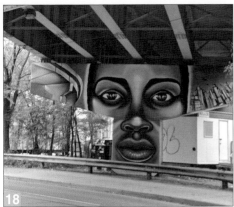

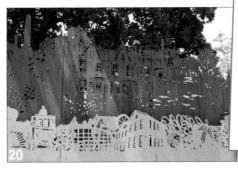

STROLL 17

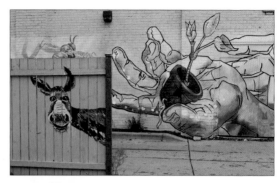

Neighbourhood
Danforth Village

Suggested walk
Around **Main Street Subway Station** (30 min to explore).

You will find the **Alleyway of Dreams** behind Main Station, in the lane by **Coleman Park**. There's street art up to Dawes Rd. **Stephenson Park** is also worth a visit, with whales all over its wading pool and a cute mural around the storage room.

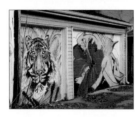

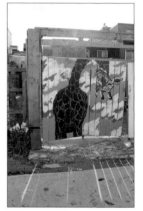

TTC & Parking
• Exit at **Main Street Subway Station**.
• It's easier to find street parking around Stephenson Park.

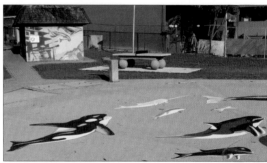

While you're here
• You've got to stop for a bite or at least a coffee at **Grumbel's Deli** (290 Main St., just south of Danforth) to enjoy truly kitsch decor. The whimsical dark little place has tables in the back.
• **Vintage Depot** (2777 Danforth Ave. W) has a huge selection of second-hand clothes for men, women and children.

STROLL 18

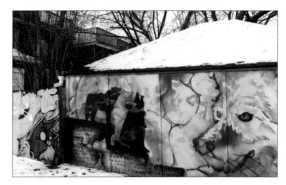

Neighbourhood
Greektown

Suggested walk
From **Chester** to
Donlands Station
(30 min to explore).

There's a walking trail
behind the three sub-
way stations, passing
through narrow par-
kettes and parking
lots. A fertile ground
for street art, look left
and right and into
the lanes as you go!
Then, there are many
little shops and res-
taurants to discover
along Danforth.

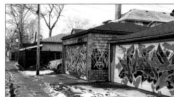

TTC & Parking
• Exit at **Donlands**,
Pape or **Chester
Subway Stations**.
• Free street parking
north of Danforth.

While you're here
• You're in Greektown.
The Greek honey balls
at **Athens Pastries**
(509 Danforth Ave) are
the best!
• **The Only Café**
(972 Danforth Ave)
is a unique café/res-
taurant/bar (25 local
brews on tap) as well
as a **Backpacker Inn**!
Plus, it has the most
whimsical facade in
Toronto.

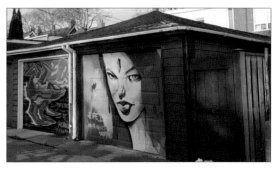

STROLL 19

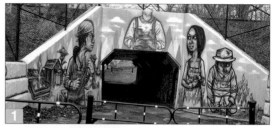

Neighbourhood
Greenwood-Coxwell + Little India

1 **Monarch Park** (south)
2 **Monarch Park** (north)
3 **Monarch Park** (rink)
4 **Patisserie La Cigogne**
5 **Red Rocket Coffee**
6 **El Sol (Mexican)**
7 **Danforth Bowl**
8 **Coxwell Walkway**
(About **artists**, see p. 190)

Suggested walk
5.2 km (1 hr 20 min)

Many murals grace the already colourful South Asian strip. At night, gorgeous saris and jewelry sparkle in the windows. At both ends, the parks add a good dose of green with their own share of murals, thanks to **Mural Routes** & **StreetART**.

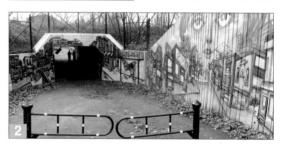

TTC & Parking
• Exit at **Greenwood** or **Coxwell Subway Stations**.
• Plenty of free street parking in dead-end streets south of **Monarch Park**, with small path leading to its southern entrance.

While you're here
• You can bowl in tiny **Danforth Bowl** (1554 Danforth) or skate in **Greenwood Park**'s lovely skating path.
• Check **www. gerrardindiabazaar. com** to find out about their next lively street event, adding music and fun to the area.

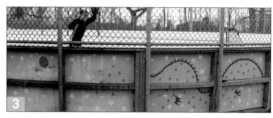

Strathmore Rd

Greenwood Station 5

6

7

Coxwell Station 8

Danforth Ave

4

N

Mount Joy Ave

Gillard Ave

Monarch Park Ave

Parkmount Rd

Felstead Ave

Patisserie La Cigogne
1419 Danforth Ave

El Sol (Mexican)
1448 Danforth Ave

Monarch Park

3

2

Red Rocket Coffee
1364 Danforth Ave

1

Hiawatha Rd

Craven Rd

Coxwell Ave

Walpole Ave

Greenwood Ave

Fairford Ave

9

Redwood Ave

Glenside Ave

Woodfield Ave

Ashdale Ave

Rhodes Ave

24 25

10 11 12 13

21 22 23

18 17

Gerrard St E

16

Gerrard St E

15

14

19

Richard Ave

Highfield Rd

Hizwatha Rd

Craven Rd

20

Greenwood Park

Dundas St E

Flying Pony Gallery
1481 Gerrard

Lahore Tikka House
1365 Gerrard St

8

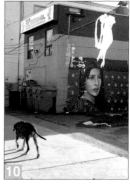

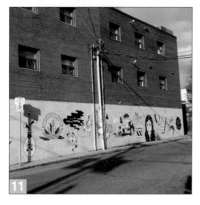

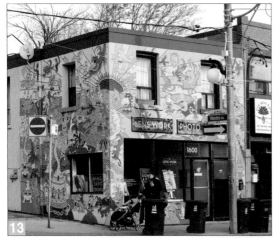

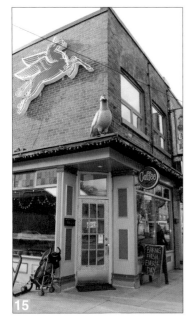

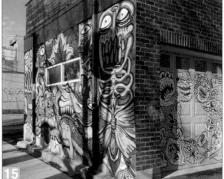

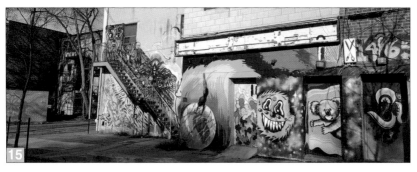

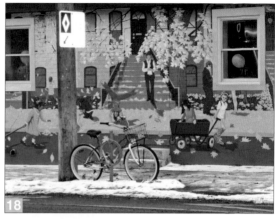

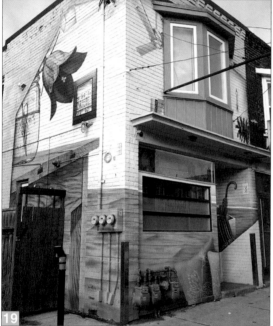

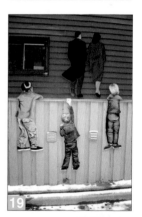

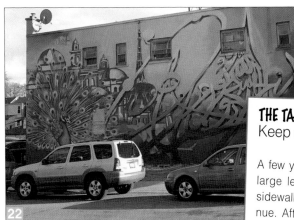

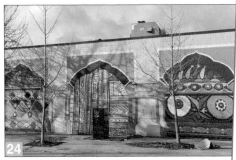

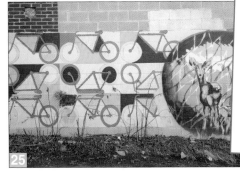

THE TAO OF STREET ART
Keep on giving!

A few years ago, I noticed large letters on the north sidewalk of Danforth Avenue. After following the A to Z trail of the *Love Letters* by artist **Victor**, I contacted him. Victor suffers from a mean form of arthritis that makes it very painful for him to paint. Despite this fact, he refreshed the letters last year and added **#whatsvictorupto** with an invitation to sponsor his work (look for his hashtag on **www.gofundme.com**). But whether we do or not, he'll keep on adding his art on sidewalks in and around the GTA as long as he can. At the time of print, the letters had faded away (as seen near **Red Rocket Coffee**) but we never know when Victor will decide to refresh them again. All municipalities should hire artists like him to create these fun trails that get us hopping over 2 kms without even realizing it.

May we all be as generous in giving the best we've got!

STROLL 20

Neighbourhood
Leslieville

Suggested walk
6.7 km (1 hr 40 min)

Queen East is lined with the labour of love of independent business owners who followed their passion. Street art simply adds to its creative vibe.

TTC & Parking
• Streetcar **501** runs along Queen.
• Free street parking after 10 a.m. on the streets north and south of Queen East.

While you're here
• The unique 50-seat **Red Sandcastle Theatre** (922 Queen St E) runs a lineup of cool co-productions.
• A bigger venue has opened: **Streetcar Crowsnest** (345 Carlaw Ave), home to the **Crow's Theatre**.
• Two lively Sunday events: See **www.leslievilleflea.com** (2nd Sunday of June to Oct, **Ashbridge Estate**) and **www.leslievillemarket.com** (Sundays, end of May to end of Oct., **Jonathan Ashbridge Park**).

1 **Barrio** (side patio)
2 **Lady Marmalade**
3 **Red Sandcastle Theatre**
4 Mural by **Herakut** at 1135 Dundas St E
5 **Dundas & Carlaw**
6 Dundas St E & Pape Ave
(About **artists**, see p. 190)

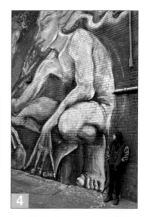

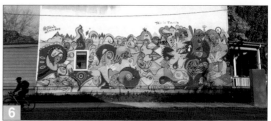

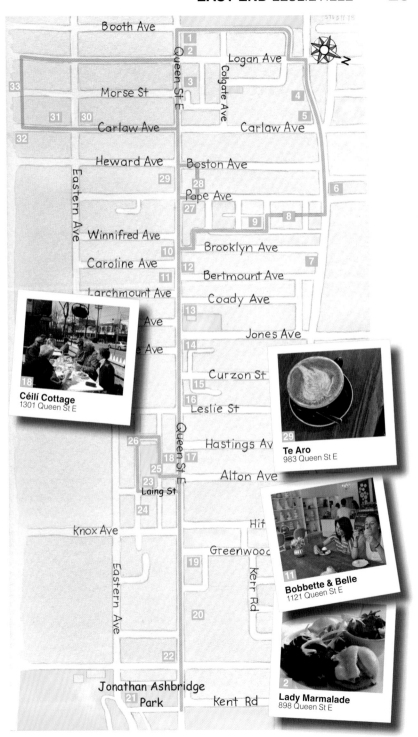

Céilí Cottage
1301 Queen St E

Te Aro
983 Queen St E

Bobbette & Belle
1121 Queen St E

Lady Marmalade
898 Queen St E

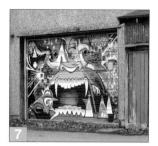

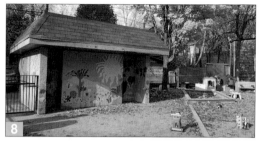

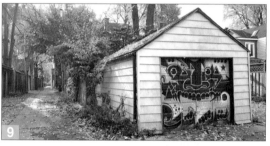

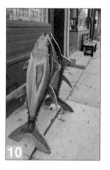

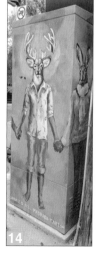

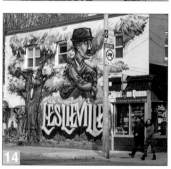

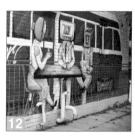

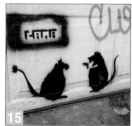

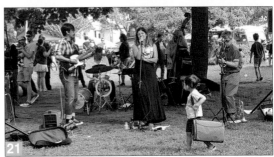

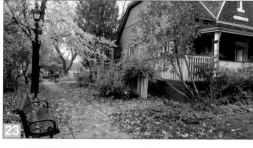

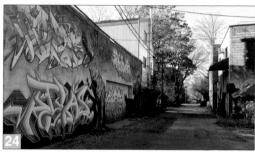

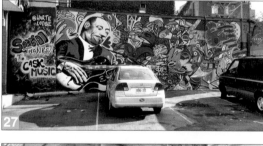

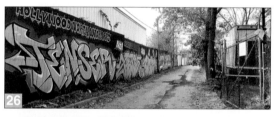

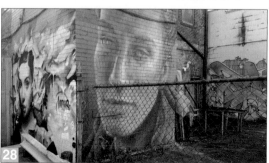

22 **Up to You** (shop)
23 **Maple Leaf Forever Park**
24 Sears St E of Laign St
25 Agnes Ln
26 Memory Ln
27 W side of **Cask Music**
28 Lane W of Pape Ave
29 1523 Dundas W (side alley)
30 Carlaw & Eastern Ave
31 N side of 96 Carlaw Ave
32 Paved path E of Carlaw
33 Art by **Omen** at Morse St & Lake Shore Blvd

(About **artists**, see p. 190)

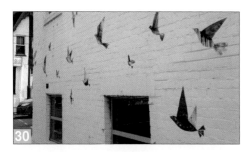

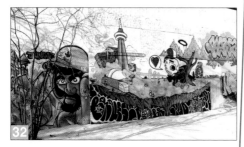

THE TAO OF STREET ART
Think big!

One week, it was just a boring brick building on Dundas Street East, Leslieville. The next, its wall hosted one of Toronto's most poetic murals, executed by the German street art duo **Herakut**. What I really like about this mural, apart from its sheer size, is the fact that it is part of their original *Biggest Storybook Project*, featuring similar murals all over the world! You can find Herakut's work in Montreal, Miami... One mural wasn't enough for the duo, it had to be part of a series. One country wasn't enough, it had to become an international project. The mural format wasn't enough, it had to spill into a book project, which evolved into two different published books, as you'll see on their website **www.herakut.com**.

Let's dare to think big, for the mere fun of it.

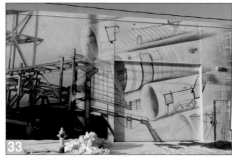

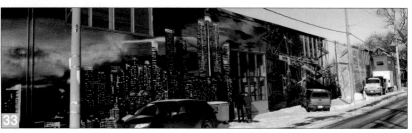

STROLL 21

Neighbourhood
Riverdale

Suggested walk
5 km (1 hr 15 min)

Nowhere else in Toronto will you get this kind of view during a sunset. Riverdale Park along Broadview overlooks downtown's high-rises. Try to make the end of your walk coincide with the sunset! The stroll includes the smaller **Chinatown** on Gerrard.

TTC & Parking
• Exit at **Broadview Subway Station**.
• After 9 am, you might find room on Broadview along the park.

While you're here
• Toronto's sunset times found on **www.timeanddate.com**: May 1st (8:20 pm), June 1st (8:50 pm), July 1st (9 pm), August 1st (8:40 pm), Sept. 1st (7:50 pm), and Oct. 1st (7 pm).
• The pedestrian bridge at the foot of **Riverdale Park** has stairs to access the **Lower Don River Trail**, meandering along the river up to **Taylor Creek Trail**, 6 km further north.

1 **Rooster Coffee House**
2 **Riverdale Park East**
3 **Allen's**
4 **Bridgepoint Healthcare**
5 **Lower Don River Trail**
6 **Zhong Hua Men Archway**
7 Side of **Chino Locos**
8 W of 598 Gerrard St E
9 **AAA Pub**
10 W of 587 Gerrard St E
11 E of 651 Gerrard St E
12 **Hailed Coffee** (Arabic)
(About **artists**, see p. 190)

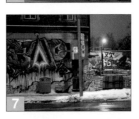

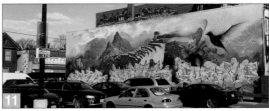

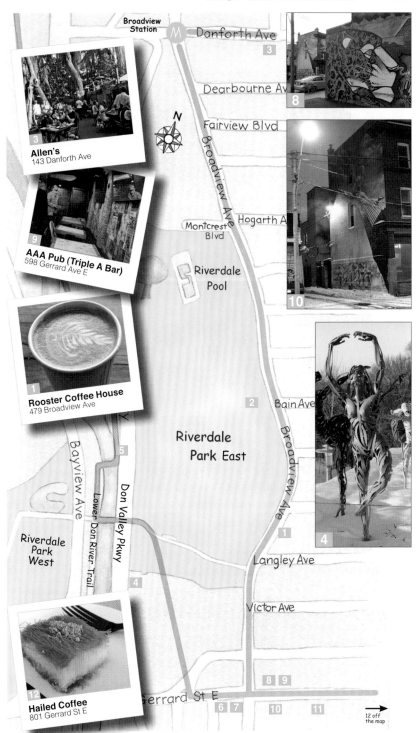

Broadview
Station

Danforth Ave 3

Dearbourne Av 8

N

Fairview Blvd

Broadview Ave

Hogarth A

Montcrest
Blvd

10

Riverdale
Pool

3
Allen's
143 Danforth Ave

9
AAA Pub (Triple A Bar)
598 Gerrard Ave E

1
Rooster Coffee House
479 Broadview Ave

2 Bain Ave

Broadview Ave

4

Bayview Ave

Lower Don River Trail

Don Valley Pkwy

5

Riverdale
Park East

Riverdale
Park
West

1

Langley Ave

4

Victor Ave

8 9

12
Hailed Coffee
801 Gerrard St E

Gerrard St E 6 7 10 11

12 off
the map

STROLL
22

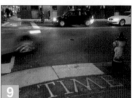

Neighbourhood
Riverside

Suggested walk
1.8 km (30 min)

It is hard to keep track of all the changes happening in Riverside neighbourhood! And the newly restored **Broadview Hotel** is setting the tone for more grand things in the vecinity. The little stretch is jam-packed with restaurants, cafés, shops and a few surprises on the side.

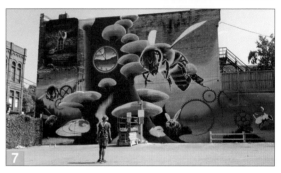

TTC & Parking
• Streetcar **501** runs along Queen.
• You can easily find street parking after 10 am on the streets north and south of Queen Street East.

While you're here
• **Boots & Bourbon Saloon** (725 Queen St E) is your chance to try line dancing, every Thursday!
• There's **Smash Ping Pong Lounge** (672 Queen St E) for games, drinks & bites.
• There's always some performance at the **Opera House** (735 Queen St E).

1 **Little Peeps**
2 Queen St E & Grant St
3 **Sweet Jesus**
4 **Mazz Japanese Bistro**
5 **Bonjour Brioche**
6 Queen St E viaduct
7 **Nick Sweetman** working at 777 Queen St E
8 **Sugar Loaf Bakery**
9 Time installation by **Eldon Garnet** on the four corners
10 **The Broadview Hotel**
11 Queen St E & Munro St
12 **Dark Horse**
13 **Cannonball**'s patio
14 **Riverside Bridge**
15 **Merchants of Green Coffee**
16 **Joel Weeks Park**
17 Grant St & Clark St
(About **artists**, see p. 190)

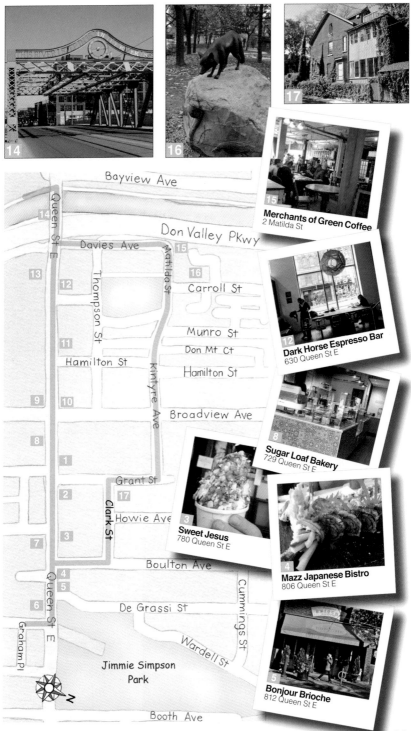

Merchants of Green Coffee
2 Matilda St

Dark Horse Espresso Bar
630 Queen St E

Sugar Loaf Bakery
729 Queen St E

Sweet Jesus
780 Queen St E

Mazz Japanese Bistro
806 Queen St E

Bonjour Brioche
812 Queen St E

Bayview Ave

Don Valley Pkwy

Davies Ave

Carroll St

Munro St

Don Mt Ct

Hamilton St

Hamilton St

Broadview Ave

Grant St

Howie Ave

Boulton Ave

De Grassi St

Wardell St

Jimmie Simpson Park

Booth Ave

Queen St E

Thompson St

Matilda St

Kintyre Ave

Clark St

Cummings St

Graham Pl

N

STROLL 23

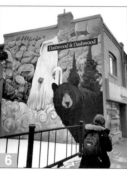
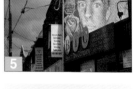
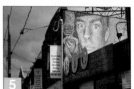

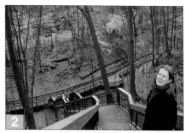

Neighbourhood
Upper Beaches + The Beach

Suggested walk
6.2 km (1 hr 30 min)

You'll want to use the street art found in the lane north of Kingston Rd as an excuse to see one of Toronto's best urban parks, **Glen Stewart Ravine**. You'll get why they call it "Upper" Beaches once you've climbed up the ravine to get there. The steep hill creates a unique street network.

TTC & Parking
• Streetcar **502** runs along Kingston Road.
• Free street parking spots on MacLean Ave, Pine Crescent, or near the ravine's entrance on Glen Manor Dr E.

While you're here
• There's a cluster of decadent places around **Fox Theatre** (2236 Queen St E): **Remarkable Bean**, **Ed's Real Scoop**, **Chocolate by Wickerhead**.
• The boardwalk is a 2-min walk south of Queen St.

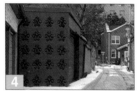

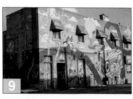

1 Pine Crescent
2 **Glen Stewart Ravine**
3 **King's Diner**
4 Jim Wilson Lane
5 Side of 947 Kingston Rd
6 Kingston & Scarborough Rd
7 **Over the Moon Bake Shop** (in Stone Pizza)
7 **Savoury Grounds**
8 Lane E of Bingham Ave
9 Kingston & Victoria Park
10 Balsam & Sycamore Pl
(About **artists**, see p. 190)

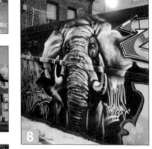

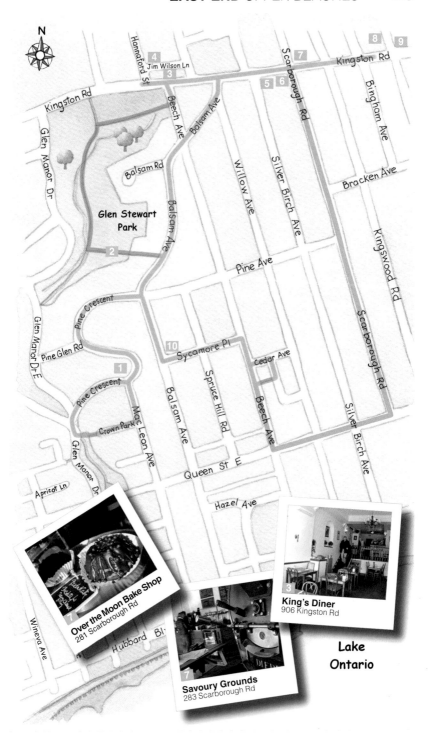

Over the Moon Bake Shop
281 Scarborough Rd

King's Diner
906 Kingston Rd

Savoury Grounds
283 Scarborough Rd

Lake
Ontario

STROLL
24

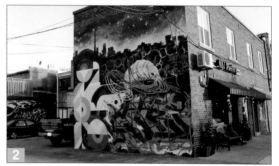

Neighbourhood
Leaside

Suggested walk
2.5 km (35 min)

Leaside is a residential area with large stores one would expect in the suburbs. Nevertheless, it hides a small alley surprisingly filled with street art.

TTC & Parking
• Bus **88** runs along Eglinton E.
• Plenty of free parking lots. The closest is at Eglinton E & Laird (near **Pier 1 Imports**).

While you're here
• There's a cluster of big stores north and south of Vanderhoof Ave, such as **Marshalls**, **HomeSense**, **PetSmart**, **Winners** and **Home Depot**.
• Great finds at Brentcliffe Rd & Vanderhoof: fancy second-hand store **Extoggery** (S/W corner) and **Urban Nature Company** (N/W corner near **Nando's**).
• There's a **Kaboom Fireworks** outlet (202 Laird Dr) at Laird & Parkhurst Blvd.

1 **Domino's Pizza**
2 Alley E of Sutherland
3 Alley between Sutherland and Laird
4 **Vanderhoof Skatepark**
5 **Charmaine Sweets**
6 Nando's
(About **artists**, see p. 190)

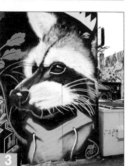

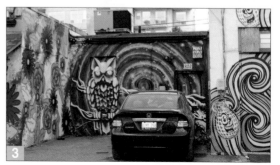

Don Avon Dr

Donlea Dr

Eglinton Ave E

Eglinton Ave E

Sutherland Dr

Laird Dr

Brentcliffe Rd

HomeSense

Vanderhoof Ave

Vanderhoof Skatepark

Parkhurst Blvd

Research Rd

Wicksteed Ave

Mc Rae Dr

Winners

Domino's
784 Eglinton Ave E

Nando's
Brentcliffe Rd & Vanderhoof Ave

Charmaine Sweets
115 Vanderhoof Ave

THE TAO OF STREET ART
It takes a village

When I visited this alley, I chatted with a local retired gentlemen, not the kind you would normally imagine appreciating street art, who was really proud of the improvement in the neighbourhood. You could feel how happy he was that the opportunity was given to young artists to perform their art on such a large canvas. **Elicser** was the first to paint in the small lane in 2007. In 2015, the community took it upon itself to bring more street artists to make something out of the boring alley. Local **Domino's Pizza** kept the talent fed. Neighbours cheered as they witnessed the transformation.

Cool things happen when the whole community is involved.

97

STROLL 25

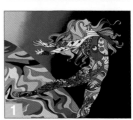

Neighbourhood
Mimico

Suggested walk
The walk around **Birds & Beans Café** (with most murals) is 2.5 km (35 min). Walking past the gazebo of the promenade up to **Humber Bay Bridge** and back will add 5.6 km (1 hr 25 min).

The aquatic theme of the fantastic mural on the side of **Birds and Beans** sets the tone to this stroll where street art spotting is just an excuse to enjoy the glistening water.

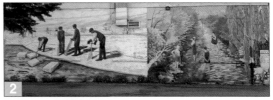

TTC & Parking
• Streetcar **501** runs along Lake Shore.
• Parking lot on W side of Mimico, N of Lake Shore. Paid parking lots in Humber Bay Park.

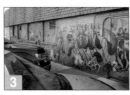

While you're here
• The **Humber Butterfly Habitat** in Humber Bay Park East is really cute. You'll see decks crossing basins nearby. They serve to filter storm water and are a good place to spot cormorants, cranes and gigantic fish!

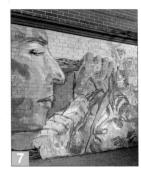

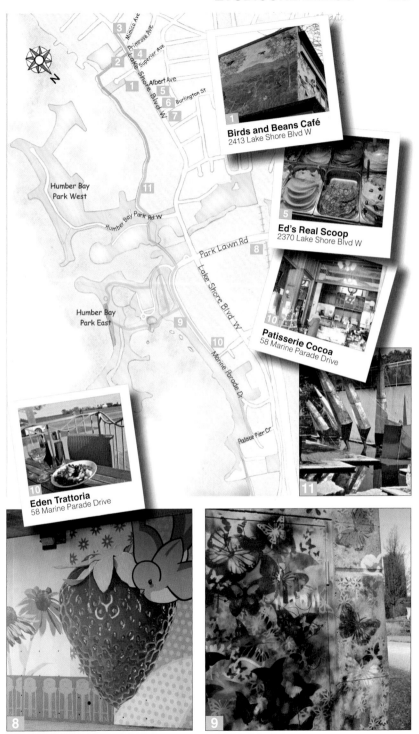

Birds and Beans Café
2413 Lake Shore Blvd W

Ed's Real Scoop
2370 Lake Shore Blvd W

Patisserie Cocoa
58 Marine Parade Drive

Eden Trattoria
58 Marine Parade Drive

Humber Bay Park West

Humber Bay Park East

STROLL
26

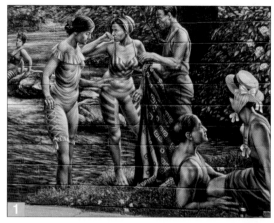

Neighbourhood
Village of Islington

Suggested walk
2.4 km (40 min)

Artist **John Kuna** has been chosen year after year by **Village of Islington BIA** to create gorgeous murals, and the unique neighbourhood now looks like an outdoor gallery. Expect small restaurants with cuisine from all over the world along Dundas St.

TTC & Parking
• **Islington Subway Station** is a 10-min walk from Dundas W.
• There's affordable parking space in the alley N of Dundas St, between Royalavon Ct and Renown Rd.

While you're here
• Down the path by **Montgomery's Inn** is lovely **Thomas Riley Park**. This adds 2 km (30 min).
• See the two murals by **Emilia Jajus** on Royal York Rd at **Dundas Underpass** (a 25-min walk east on Dundas, taking The Kingsway N, turning E on Lambeth Rd, then S on Royal York Rd).

1 5126 Dundas W
2 5112 Dundas W
3 5110 & 5096 Dundas W
4 **European Patisserie**
5 5048 Dundas W
6 4994 Dundas W
(About **artists**, see p. 190)

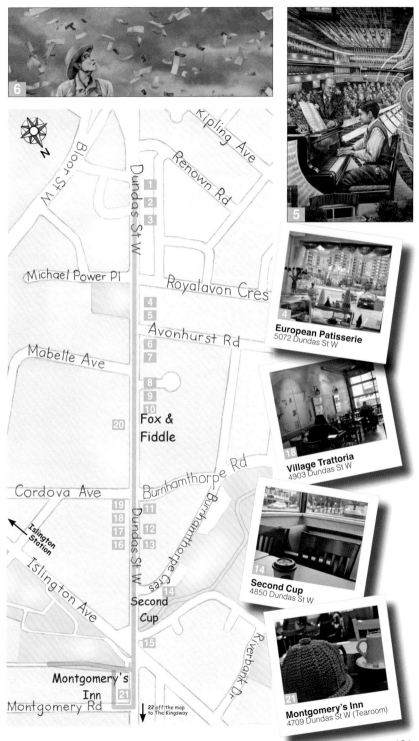

European Patisserie
5072 Dundas St W

Village Trattoria
4903 Dundas St W

Second Cup
4850 Dundas St W

Montgomery's Inn
4709 Dundas St W (Tearoom)

Fox & Fiddle

Second Cup

Montgomery's Inn

Islington Station

22 off the map to The Kingsway

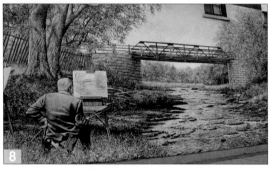

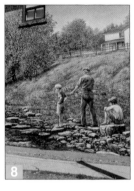

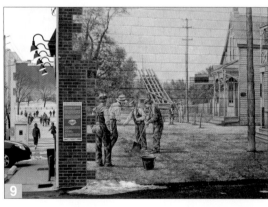

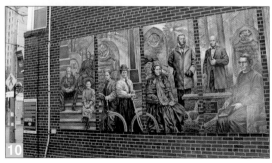

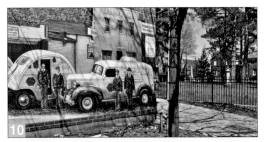

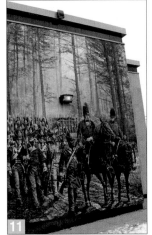

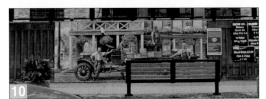

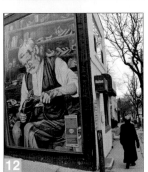

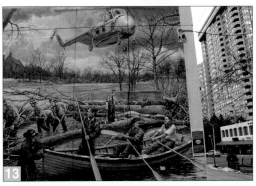

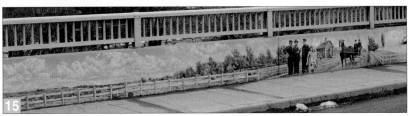

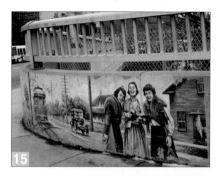

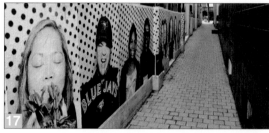

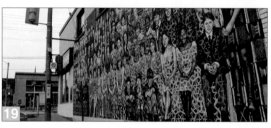

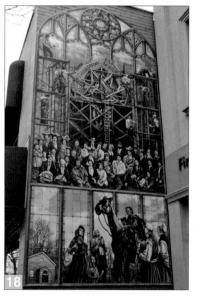

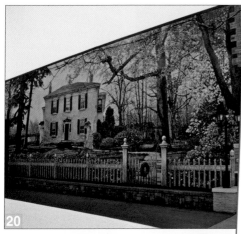

About the BIAs

There are 82 BIAs representing over 35,000 businesses in Toronto.

A BIA is an association of commercial property owners and tenants within a defined area. BIA stands for **Business Improvement Area**. Toronto welcomed the first in 1970. By working collectively, local businesses have the organizational and funding capacity for marketing, promotion, festivals and neighbourhood beautification projects. Some projects add to the quality of life in their neighbourhood (ex. the colourful benches of **Leslieville BIA** and **Gerrard India Bazaar BIA**). Others literally put their area on the map. **Village of Islington BIA** is one of them. By commissioning artist **John Kuna** to paint most of the murals, it has given a strong and unique personality to the area. (So did **Dundas West BIA**, see Stroll 39 on p. 142.)

Search *BIA Listing* in **www1.toronto.ca** to access links to every BIA, with maps, contacts, information about their business mix and more.

STROLL 27

Neighbourhood
Deer Park

Suggested walk
Around **St. Clair Subway Station**
0.9 km (15 min)

You will find one of Toronto's tallest murals on St. Clair west of Yonge, hidden from sight. Walk past **JJ Bean Coffee Roasters** (2 St. Clair W), turn around, and look up! Can you spot the CN Tower and other landmarks in the giant person by UK-based street artist **Phlegm**?

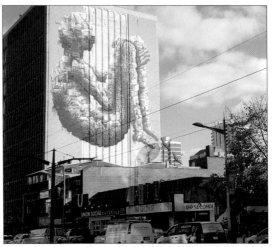

TTC & Parking
• Exit at **St. Clair Subway Station**, go west of Yonge.
• **Green P** parking one street S of St. Clair at 2 Pleasant Blvd.

While you're here
• This is a good opportunity to visit **Mount Pleasant Cemetery** (a 10-min walk north of St. Clair on the east side). Far from sinister, it counts many sculptures adorning the graves. Splendid in the fall.
• **Midtown Gastro Hub** (1535 Yonge St) has a nice rooftop patio.

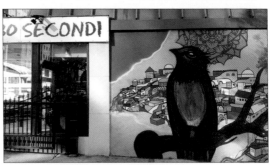

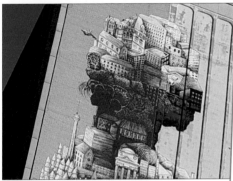

About the STEPS Initiative
They started in 2011 as an incubated project of the Centre for Social Innovation, incorporated as an independent non-profit organization in 2014, and registered as a charity in 2016.

It is the award-winning public arts organization behind Toronto's tallest murals such as the one in this stroll and the one in **St. James Town** in Stroll 14 (see p. 58). The **Patch Project** is their initiative (see p. 63). The STEPS Initiative provides a platform for Torontonians to lead initiatives that validate their personal experiences, their community's cultures and histories, and their concern for social and environmental issues. Learn more at **www.stepsinitiative.com**.

Using art to connect people to public spaces, one at a time.

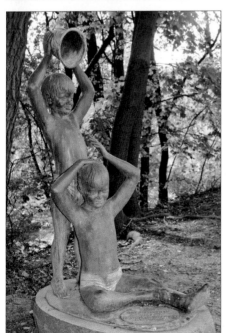

STROLL
28

Neighbourhood
**Forest Hill
+ Fairbank**

Suggested walk
It is 6 km (1 hr 30 min) from the murals at Eglinton W to the ones at Dufferin, and back.

There's street art along the **Beltline Trail** at Eglinton W and Dufferin St, E & W of Allen Rd, reason enough to include it in this guide!

TTC & Parking
• Exit at **Eglinton West Subway Station** (go E on Eglinton, turn left on Glenarden Rd and left on Wembley Rd to reach the path).
• Free street parking north of Elm Ridge Dr.

While you're here
• **Mount Pleasant Cemetery** is a 30-min walk eastbound from Eglinton, on the Beltline.
• The **Dufferin Underpass** is a 15-min walk westbound from Eglinton. Walk 15 min more to reach Caledonia and **W Burger Bar**. Note that west of Allen Rd, you access the trail from Beograd Gardens (off the map).

1 **Hotel Gelato**
2 Stairs off Eglinton W (E of Spadina Rd)
3 Eglinton W Underpass
4 East of Allen Rd
5 **Beltline** at Dufferin St
6 **Adventure Cycle** at 2464 Dufferin St
7 **W Burger Bar** S of Beltline on Caledonia
(About **artists**, see p. 190)

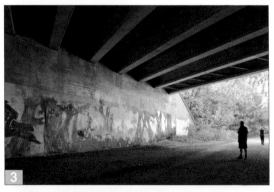

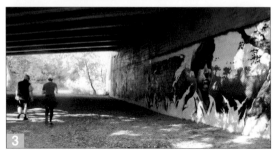

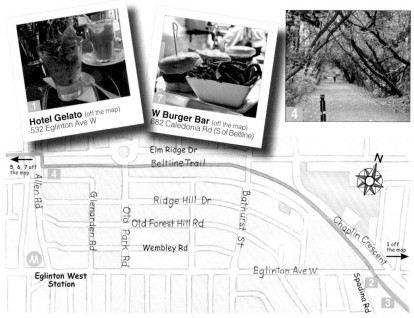

Hotel Gelato (off the map)
532 Eglinton Ave W

W Burger Bar (off the map)
682 Caledonia Rd (S of Beltline)

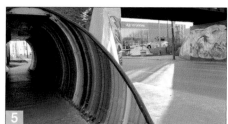

5, 6, 7 off the map

Elm Ridge Dr

Beltline Trail

Ridge Hill Dr

Old Forest Hill Rd

Wembley Rd

Allen Rd

Glenarden Rd

Old Park Rd

Bathurst St

Chaplin Crescent

Eglinton Ave W

1 off the map

Eglinton West Station

Spadina Rd

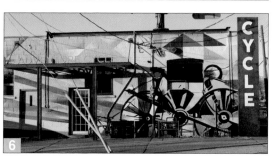

STROLL
29

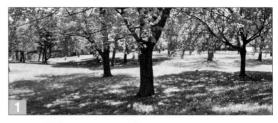

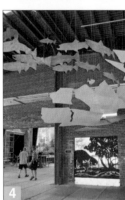

Neighbourhood
Rosedale

Suggested walk
3.9 km (1 hr)

Evergreen Brick Works is Toronto's best success story of rejuvenation of an historic site. Everywhere you turn, there are reminders of the origin of the site as Toronto's prominent brick factory, and of its period of abandon (hence the graffiti).

TTC & Parking
• Catch a free shuttle bus to **Evergreen** from the parkette just north of **Broadview Subway Station** (for schedule, search *shuttle bus* on **www.evergreen.ca**).
• You can park for the day for $8 at **Brick Works** or there's free street parking around **Chorley Park** (a 10-min walk).

While you're here
• Check the **Brick Works**' *What's On* on their website. Look for free outdoor jazz!
• Walk northbound for 30 min on **Moore Trail** to reach **Mount Pleasant Cemetery**.

1 **Chorley Park**
2 **Moore Ravine**
3 Trails off **Moore Ravine** going to **Chorley Park**
4 **The Pavilions**
5 Fire pit around the market
6 West entrance
(About **artists**, see p. 190)

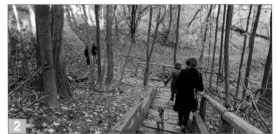

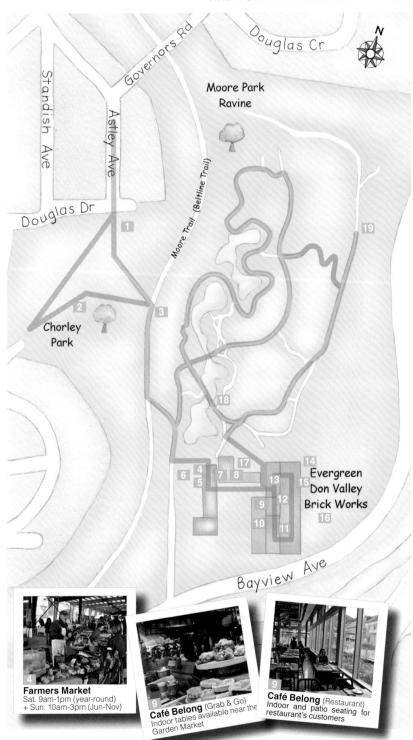

Standish Ave

Governors Rd

Douglas Cr

N

Astley Ave

Moore Park
Ravine

Douglas Dr

Moore Trail (Beltline Trail)

1

19

2

Chorley
Park

3

18

17

14 Evergreen
Don Valley
Brick Works

6 4 7 8
5 13 15

9 12

10 11 16

Bayview Ave

Farmers Market
Sat. 9am-1pm (year-round)
+ Sun. 10am-3pm (Jun-Nov)

Café Belong (Grab & Go)
Indoor tables available near the
Garden Market

Café Belong (Restaurant)
Indoor and patio seating for
restaurant's customers

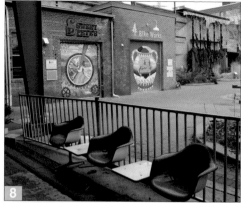

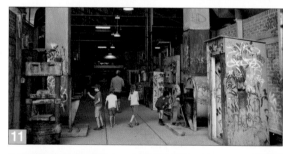

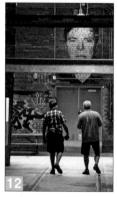

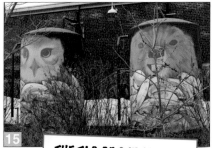

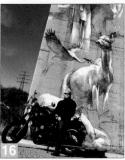

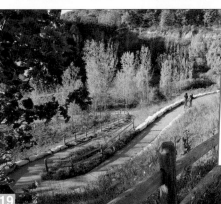

THE TAO OF STREET ART
Don't forget...

In and around the buildings of **Evergreen Brick Works** you can still see some of the original graffiti, a reminder of the time when the only people who understood the value of the abandoned place were street artists. The will behind the decision to keep the graffiti certainly influenced all the other artsy decisions: the art done with artifacts, the large public artworks on the central wall and under the roof of the market place, the giant flower hanging from a historical window, and now a giant photography installation by **Edward Burtynsky** on the south wall of the **Young Welcome Centre**. Art everywhere is serving as a bridge between history and our present urban life.

Remembering where we come from helps us build on the good we created.

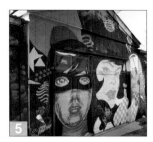

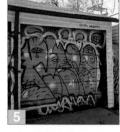

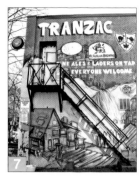

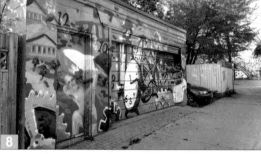

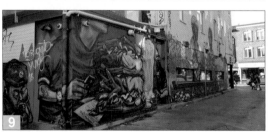

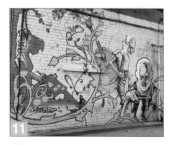

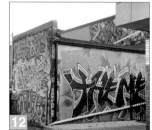

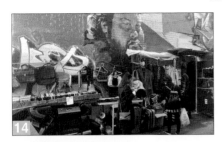

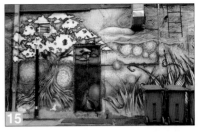

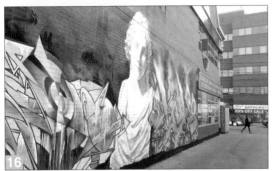

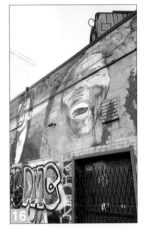

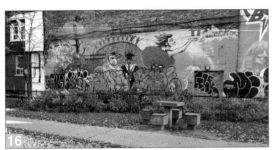

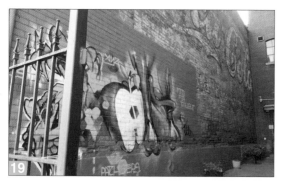

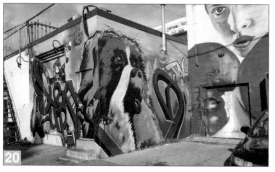

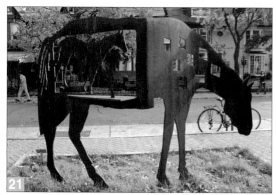

19 **Centre for Social Innovation - Annex**
20 Honest Ed Alley
21 Markham Street
Note: 23 of the 27 Heritage buildings in the area will be preserved under the new development.
22 **Snakes & Lattes**
23 Palmerston Square
24 Mission House Ln
25 Bloor W & Euclid Ave
26 **Hodo Kwaja**
27 **Native Youth Resource Centre**
28 **Black Rock Coffee** and **Basecamp Climbing**
29 **Coffee Pocket**
30 Lane E of Clinton St
(About **artists**, see p. 190)

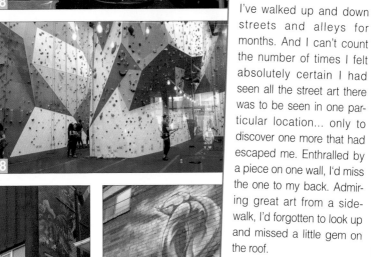

THE TAO OF STREET ART
Get some perspective

I've walked up and down streets and alleys for months. And I can't count the number of times I felt absolutely certain I had seen all the street art there was to be seen in one particular location... only to discover one more that had escaped me. Enthralled by a piece on one wall, I'd miss the one to my back. Admiring great art from a sidewalk, I'd forgotten to look up and missed a little gem on the roof.

We miss out on the fun when we stick to one angle!

STROLL
31

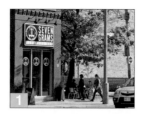

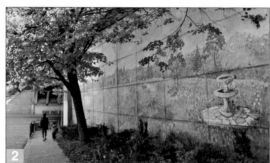

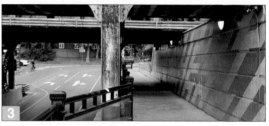

Neighbourhood
**Wychwood Park
+ Davenport**

Suggested walk
The walk around Dupont is 5.9 km (1 hr 30). Add 5.2 km (1 hr 20) to include Wychwood Park walk.

This stroll runs through all the underpasses with murals off Dupont, many included in Wychwood Park neighbourhood. It also goes through **Wychwood Park**, one of Toronto's few private streets (managed by the residents).

TTC & Parking
• Exit at **Dupont Subway Station**.
• Plenty of free street parking all around.

While you're here
• The **Spadina House** (285 Spadina Rd) is your chance to imagine a wealthy life in the early 1900s. Check out the gardens! **Casa Loma** next door is also impressive, especially during special events (**www.casa-loma.ca**).
• The **Baldwin Steps** in-between offer a view, and a workout!

1 **5 Elements Espresso** (formerly **Seven Grams**)
2 Avenue Rd & Macpherson
3 Dupont & Davenport
4 **Big Crow** (back patio) + **Rose & Sons** (diner)
5 Dupont & Spadina
(About **artists**, see p. 190)

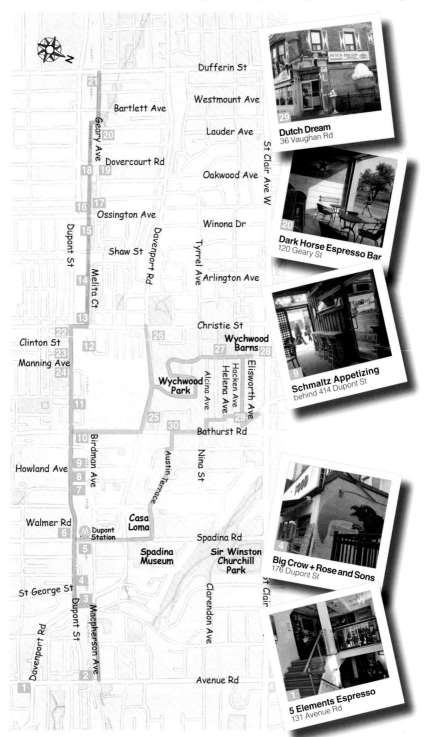

Dufferin St

Westmount Ave

Lauder Ave

Bartlett Ave

Oakwood Ave

Geary Ave

Dovercourt Rd

Winona Dr

St Clair Ave W

Ossington Ave

Dupont St

Shaw St

Davenport Rd

Tyrrel Ave

Melita Ct

Arlington Ave

Christie St

Clinton St

Wychwood Barns

Manning Ave

Hacken Ave

Helena Ave

Elisworth Ave

Wychwood Park

Alcina Ave

Bathurst Rd

Birdman Ave

Austin Terrace

Nina St

Howland Ave

Casa Loma

Walmer Rd

Dupont Station

Spadina Rd

Spadina Museum

Sir Winston Churchill Park

St George St

Dupont St

Clarendon Ave

St Clair

Macpherson Ave

Davenport Rd

Avenue Rd

Dutch Dream
36 Vaughan Rd

Dark Horse Espresso Bar
120 Geary St

Schmaltz Appetizing
behind 414 Dupont St

Big Crow + Rose and Sons
176 Dupont St

5 Elements Espresso
131 Avenue Rd

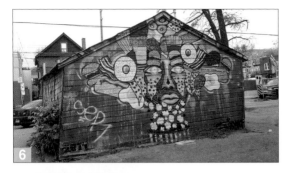

6 Behind the first building in lane facing the station
7 370 Dupont St
8 **Creeds Coffee Bar**
9 **Schmaltz Appetizing** behind **Fat Pasha**
10 Dupont & Bathurst
11 524 Dupont St
12 **Loblaws**
13 Dupont & Christie
14 **Frankel Lambert Park**
15 **Garrison Creek Park**
16 Dupont & Ossington
17 **Geary Avenue Parkette**
18 Dupont & Dovercourt
(About **artists**, see p. 190)

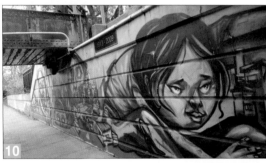

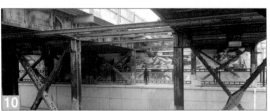

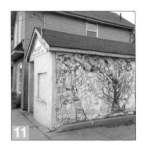

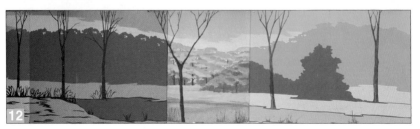

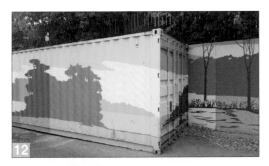

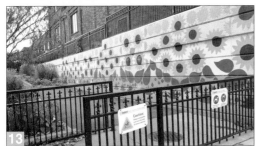

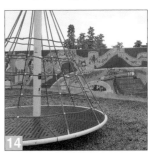

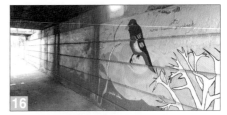

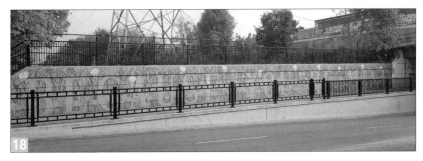

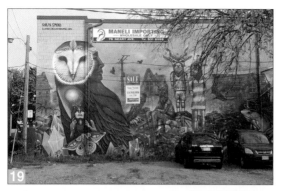

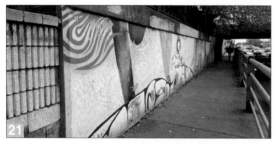

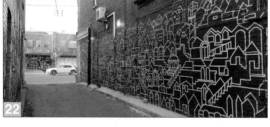

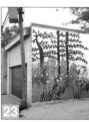

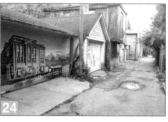

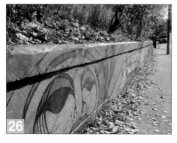

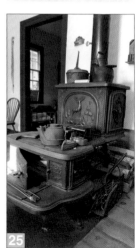

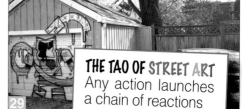

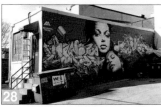

THE TAO OF STREET ART
Any action launches a chain of reactions

I was intrigued when I saw my first concrete **Lovebot** at **The Distillery**. When I noticed a second one in Leslieville, I was hooked. I eventually found out the sculptures were the creations of **Matthew Del Degan**, who would leave them to acknowledge people or groups responsible for acts of kindness. I've since seen Lovebots of all sizes appear in the form of stickers, posters, and murals throughout the city! Many of them can be seen around **Chinatown** (**Stroll 4** on p. 22) and **Kensington Market** (**Stroll 12** on p. 50). There even was one INSIDE my local mailbox, reminding us that we're quite lucky not to be stuck in a box! (It has been removed since.) Del Degan has launched a line of gadgets and toys, sold in a few cool stores in Toronto. See **www.lovebot.com**.

One thing leads to another when we are in action. Who knows where it will take us!

STROLL
32

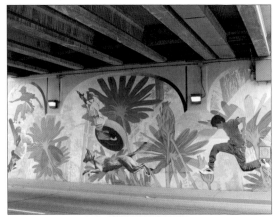

Neighbourhood
Bayview Village

Suggested walk
Around **Leslie Subway Station**.

It's hard to admire the beautiful murals on both sides of the underpass on Sheppard when you fly by in a car. They are from artist **Bill Wrigley**, the same artist who created the murals for Mural Routes near Rosetta McClain Gardens (see p. 134). You can then walk east for 2 min to Old Leslie St to access the ravine entrance to the **Don River Trail**. It meanders and crosses bridges up to Finch, 3 km away.

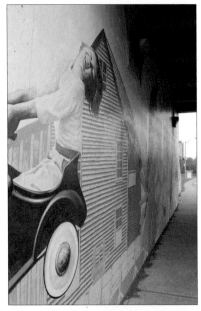

TTC & Parking
• Exit at **Leslie Subway Station**.
• Free parking lot just off Old Leslie St.

While you're here
• **IKEA**, a 10-min walk away (going W on Sheppard and down Provost Dr).
• Decent pastries await in unassuming **Café Maxim's** at 676 Finch Ave E (5 min W of the ravine's exit.

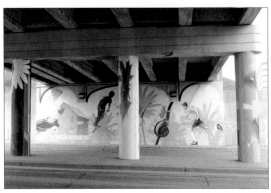

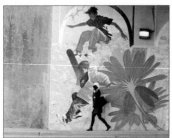

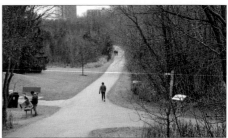

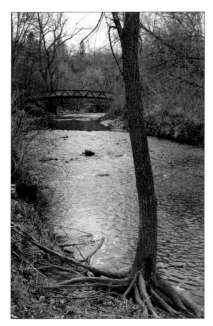

STROLL
33

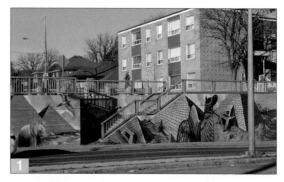

Neighbourhood
**Brookhaven-Amesbury
+ Briar Hill-Belgravia**

Suggested walk
3.1 km (45 min)

Toronto's longest mural runs along Lawrence West over 300 metres. The spectacular theme is a concept by artists **Shalack Attack**, **Fiya Bruxa** and **Bruno Smoky** (**Essencia Art Collective**).

TTC & Parking
• Bus **52** runs along Lawrence W.
• Park on Treelawn Pkwy and walk down the stairs for the best way to enjoy the mural!

While you're here
• **North Park** offers a 1.2 km-long path through the forest.
• **York Beltline Trail** is a 1.5 km walk from **Ace Bakery**, with entrance off Caledonia, just north of a popular burger place **W Burger Bar** (682 Caledonia Rd). The trail reaches **Kay Gardner Beltline Trail** (on the other side of Allen Rd) in 2.4 km. It continues eastbound for 9.46 km.

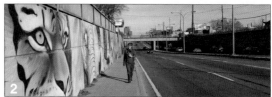

1 Staircase from Treelawn Pkwy to Lawrence W
2 Lawrence Ave W, west of the staircase
3 Lawrence Ave W, east of the staircase
4 Lawrence Ave W
5 Lawrence & Caledonia
6 **Ace Bakery**
(About **artists**, see p. 190)

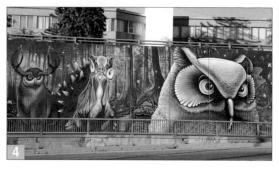

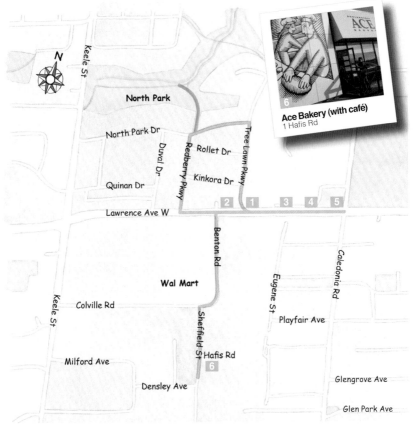

Keele St

North Park

North Park Dr

Duval Dr

Redberry Pkwy

Rollet Dr

Tree Lawn Pkwy

Kinkora Dr

Quinan Dr

2 | 1 | 3 | 4 | 5

Lawrence Ave W

Benton Rd

Wal Mart

Keele St

Colville Rd

Sheffield St

Milford Ave

Densley Ave

Hafis Rd

6

Eugene St

Caledonia Rd

Playfair Ave

Glengrove Ave

Glen Park Ave

6
Ace Bakery (with café)
1 Hafis Rd

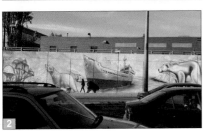

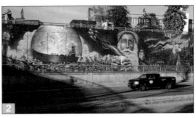

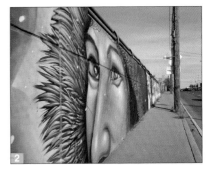

Neighbourhood
**Parkway Forest
+ Henry Farm**

Suggested walk
Go S of **Don Mills
Subway Station**
along Don Mills Rd,
then E on Helen Lu
Rd, N on Manor Rd,
then W on the 2nd
street, back to the
station (15 min walk).

You would not assume
the land of luxury
condos to be a whim-
sical place but this
one is, thanks to the
**Percent for Public
Art Program** (see p.
191) which supported
the art installation *Four
Seasons* by **Douglas
Coupland** inspired by
pencil crayons!

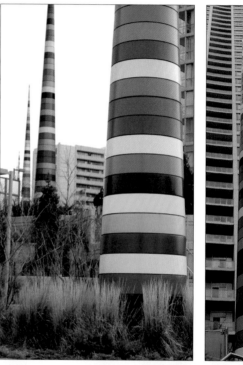

TTC & Parking
• Exit at **Don Mills
Subway Station**.
• You can park in **Fair-
view Mall**'s parking
lot (Sheppard Ave E &
Don Mills Rd).

While you're here
• A good time to visit
Fairview Mall (with
food court).
• It is a 1.7 km (25
min) walk westbound
on Sheppard to reach
the great murals of
Stroll 32, p. 126.

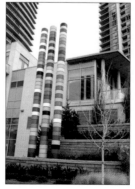

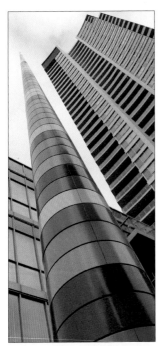

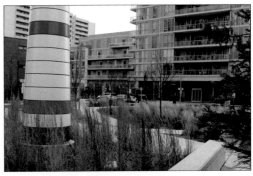

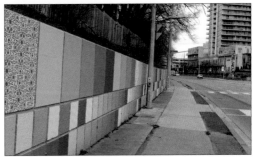

STROLL
35

Neighbourhood
**Wilson Heights
+ Yorkdale**

Suggested walk
The murals are right by the exit of **Wilson Subway Station**. A pedestrian bridge gives easy access to the S side of Wilson (5-min walk).

Once again, the team of street artist **Shalak Attack** and her collaborator **Bruno Smoky** have worked their magic. You can't fully appreciate the powerful art if you just drive by. You've got to walk around the 40 pillars to truly admire the art.

TTC & Parking
• Exit at **Wilson Subway Station**.
• You can park around **Second Cup** (693 Wilson Ave) and walk to the station past Allen Rd.

While you're here
• If you feel like walking 2.3 km (35 min), you could check out the street art at the exit of **Yorkdale Subway Station** (going W on Wilson, then S on Dufferin, walk through **Yorkdale Shopping Centre** to the station).

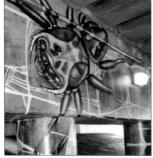

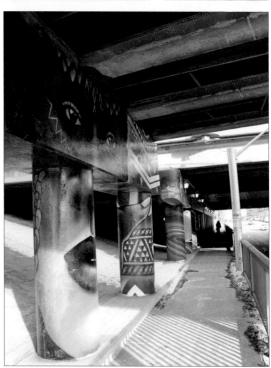

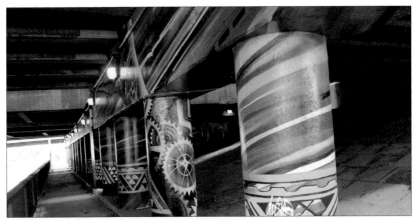

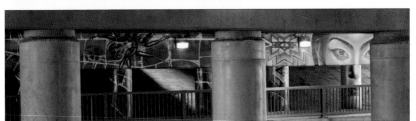

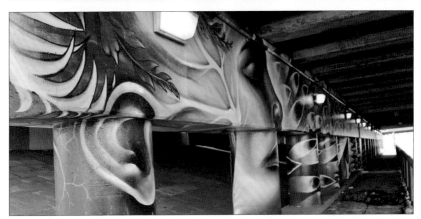

STROLL 36

Neighbourhood
**Birch Cliff
+ Cliffside**

Suggested walk
6.5 km (1 hr 40 min) from Warden to Midland and back.

This stroll covers most of **Mural Routes**' murals in Scarborough. **Rosetta McClain Gardens** is the centre point of the circuit (which continues off the map over 1.4 km on Kingston Rd). It is a 5-min walk from the ambitious murals by **Bill Wrigley**. It offers a breathtaking view of **Lake Ontario**. And you can walk down the closed road between Wynnview Ct & Fishleigh Dr to admire the white cliffs.

TTC & Parking
• Bus **12** stops at **Rosetta McClain Gardens**.
• There's free parking at the **Gardens**.

While you're here
• *Passage* by **Marlene Hilton-Moore** stands by the lake off **Doris McCarthy Trail** (acces from Ravine Dr, five streets E of Scarborough Bluffs Dr).

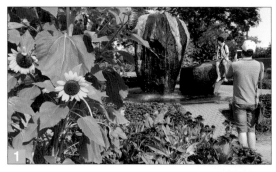

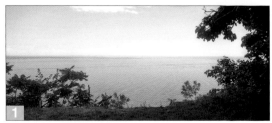

1 **Rosetta McClain Gardens**
2 Underpass at Kingston Rd & Danforth Ave
3 **Scarborough Heights Park** by the water
4 Side of 2435 Kingston
(About **artists**, see p. 190)

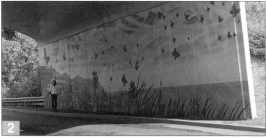

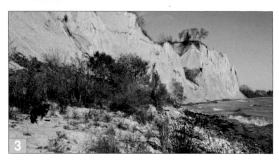

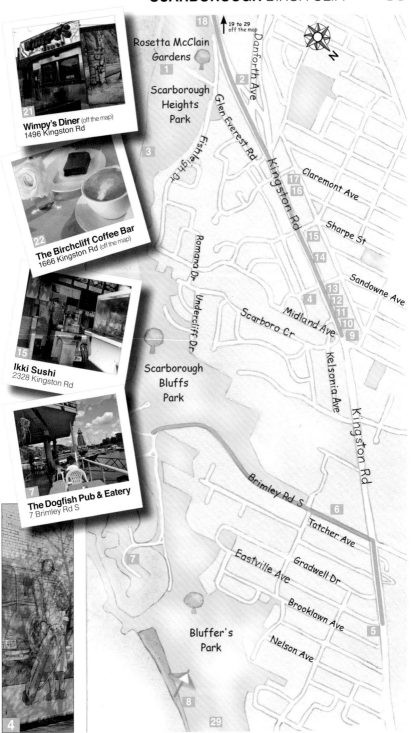

Wimpy's Diner (off the map)
1496 Kingston Rd

21

The Birchcliff Coffee Bar
1666 Kingston Rd (off the map)

22

Ikki Sushi
2328 Kingston Rd

15

The Dogfish Pub & Eatery
7 Brimley Rd S

7

4

19 to 29
off the map

Rosetta McClain
Gardens

1

Scarborough
Heights
Park

Danforth Ave

Glen Everest Rd

Fishleigh Dr

Kingston Rd

Claremont Ave

Sharpe St

Sandowne Ave

Romano Dr

Undercliff Dr

Scarboro Cr

Midland Ave

Kelsonia Ave

Kingston Rd

Scarborough
Bluffs
Park

Brimley Rd S

Tatcher Ave

Eastville Ave

Gradwell Dr

Brooklawn Ave

Nelson Ave

Bluffer's
Park

3

17
16

15

14

13
12
11
10
9

4

6

7

8

29

5

2

18

135

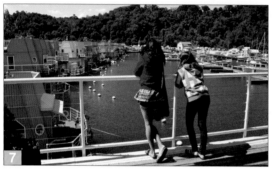

5 Side of 2835 Kingston
(note that it represents
the R H King Academy
across the street) and
the side of **Wild Wing**
6 Off Brimley Rd S
7 Boathouses around
The Dogfish Pub
8 **Bluffers's Park**
9 Side of 2502 Kingston Rd
10 W of 2472 Kingston Rd
11 **Aïoli Bistro**
12 E of 2434 Kingston Rd
13 Side of 2384 Kingston Rd
14 Left and right of 2346
Kingston Rd
15 Around **Ikki Sushi**
(About **artists**, see p. 190)

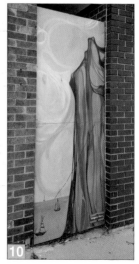

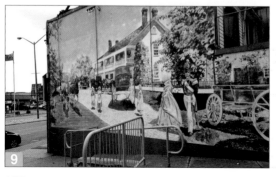

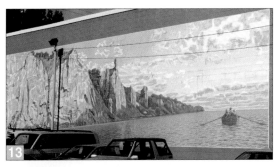

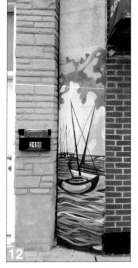

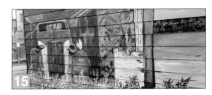

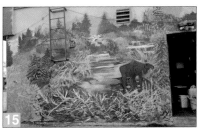

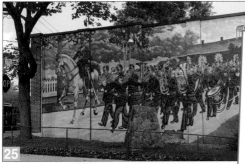

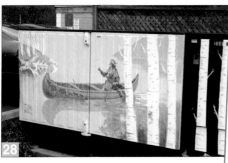

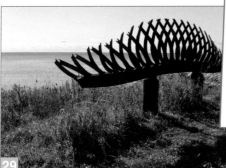

About MURAL ROUTES
It started in 1990 as a public art project of **Scarborough Arts**, aiming to celebrate the local heritage with the original mural route along Kingston Rd.

Mural Routes was later incorporated as a separate organization, creating, promoting, educating, advising and linking artists, organizations and others that are interested in the development of wall art in the Greater Toronto Area and beyond. They have since become the primary advisor for communities engaged in producing public wall art with initiatives such as MURALI, a continuum of training programs. They connect their artist members with local and international commissions and competitions.

Check the *Mural Map* section on **www.muralroutes.ca**, which they envision as a portal where artist members throughout Canada will be able to promote their murals!

139

STROLL
37

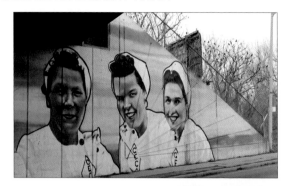

Neighbourhood
Birchmount Park

Suggested walk
The murals are at St. Clair Underpass, just north of **Warden Subway Station** (5-min walk) but you will want to explore **Warden Woods** (access on S/W corner of St. Clair and Warden)

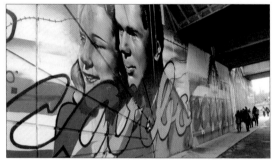

The two murals by artist **Omen** with collaborator **Horus** are spectacular and worth the visit if combined with a nature walk (the **Warden Forest** trail leads you in 30 min to Pharmacy Ave).

TTC & Parking
• Exit at **Warden Subway Station**.
• There's free street parking on Moreau Trail (one street W of Warden).

While you're here
• The **West Scarborough Community Centre** is a 15-min walk from the park's exit on Pharmacy Ave. Its entrance (shared with **Byng Park**) is marked by the cutest street art alley and the Centre's exterior walls are covered with great art! Count 6 km (1 hr 30 min) for the full circuit.

STROLL
38

Neighbourhood
Scarborough Junction + Kennedy Park

Suggested walk
Around **Kennedy Subway Station** 1 km (15 min).

The large mural painted by **Frank Perna** in 1997 still holds court on two walls of the **Kennedy Station**! Off the eastern exit of the station, look for an interesting vintage mural slowly fading out of sight on the exterior wall along the track. There are interesting sport-themed community murals near the washrooms of the **Don Montgomery Community Centre** (200 m east of the station).

TTC & Parking
• Exit at **Kennedy Subway Station**.
• There's a free parking lot near Yal Market.

While you're here
• The **Yal Market** (500 m east of the station at 2499 Eglinton Ave E) is a fun stop to find grocery items not seen in the major chains.

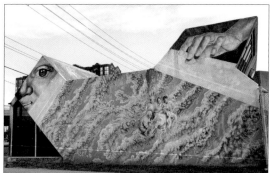

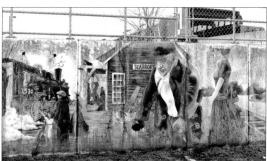

STROLL
39

Neighbourhood
**Dundas West
+ Brockton Village
+ Little Portugal**

Suggested walk
2.7 km (40 min)

Dundas West BIA has chosen artist **Jose Ortega** to brand the area and it looks wonderful! **Jarus** treats us with a couple of pieces. **Shalak** and **Smoky** with peers go wild around Lula Lounge.

TTC & Parking
• Streetcar **505** runs along Dundas W.
• Free street parking all around.

While you're here
• **Lula Lounge** (1585 Dundas W) is a cool venue/restaurant.
• **Dufferin Grove Park** is a 10-min walk north of Dundas.

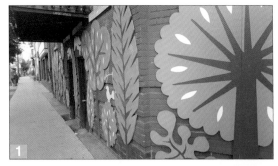

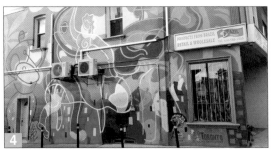

1 Dundas W & Gladstone
2 Alley E of Gladstone
3 Alley W of Gladstone
4 Dundas W & Federal
5 Dundas W & Dufferin
6 W of 1505 Dundas W
(About **artists**, see p. 190)

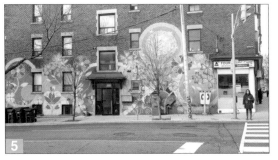

Run and Gun Coffee
1541 Dundas St W

Cygnet Coffee
1691 Dundas St W

DeFloured
1250 College St

Full of Beans Roastery
1348 Dundas St W

Junked Food
1256 Dundas St W

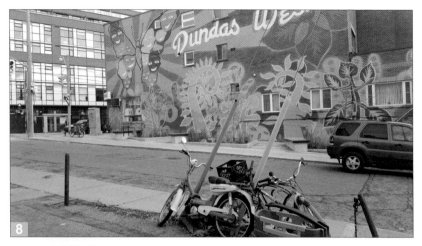

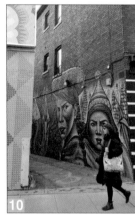

7 **Run and Gun Coffee**
8 Dundas W & Sheridan
9 1575 Dundas W
10 **Lula Lounge** and
 side alley
11 Back of 1615 Dundas W
12 Brock & Hickson
13 Dundas W & Brock
14 Side of 1637 Dundas W
15 **Cygnet Coffee**
16 Dundas W & St Clarens
17 Dundas-St Clarens Park
18 Dundas W & Lansdowne
(About **artists**, see p. 190)

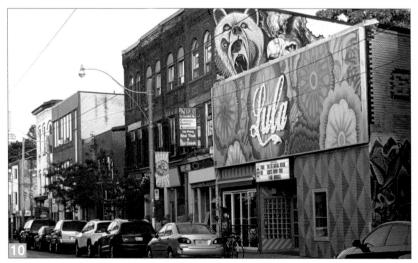

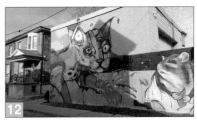

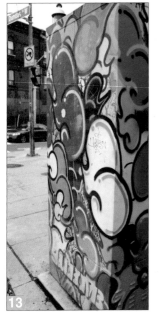

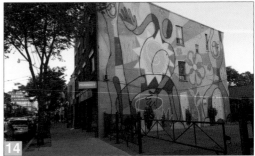

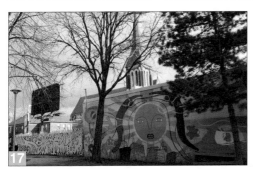

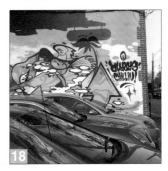

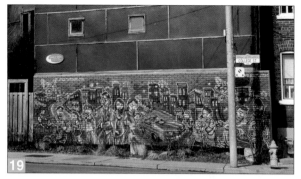

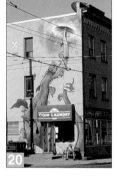

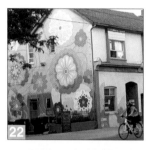

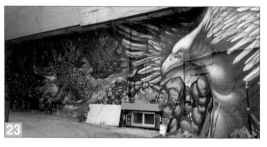

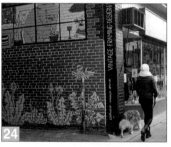

(About **artists**, see p. 190)

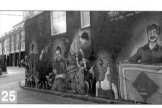

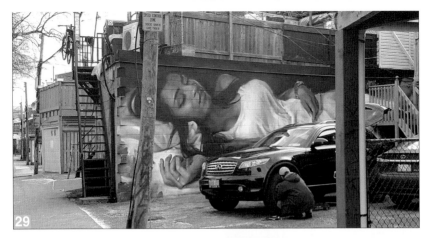

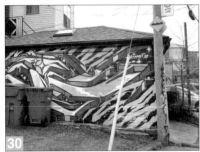

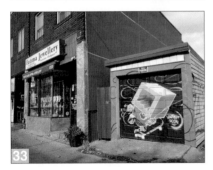

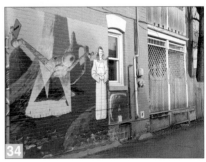

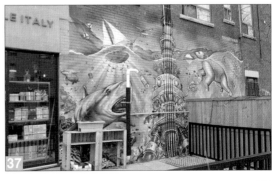

STROLL 40

Neighbourhood
High Park-Swansea

Suggested walk
7.9 km (2 hrs)

It would be sad to be in the area and not take a walk in High Park! But if you are in a hurry, it is a 2.5 km (35 min) walk from **High Park Station** to the murals in **Ravina Gardens Park** and back. Exploring the graffiti alley east of **Keele Station** is a 1.1 km (16 min) walk, back and forth.

TTC & Parking
• Exit at **High Park** or **Keele Subway Stations**.
• There's a large free parking lot by **Grenadier Restaurant**. In the spring, you can also access the park from High Park Blvd and park near the zoo.

While you're here
• **High Park**'s cherry trees blossom between mid-April to early May! (Visit *Cherry Blossom* on **www.highparktoronto.com** for updates.) Most trees are located down the Cherry Tree Lane by the **Grenadier Pond**.

1 **Grenadier Restaurant** (with labyrinth north of the parking lot behind the restaurant)
2 Cherry Tree Lane
3 **Hillside Gardens**
4 **Grenadier Pond**
5 Viaduct on Clendenan Ave
6 Graffiti alley in the back of **Ravina Gardens** (follow Glendenan, off the map)
7 Graffiti alley W & E of Indian Rd, and past Dorval St
8 **Outpost Coffee Roasters** around Dorval Rd at 1578 Bloor St W
(About **artists**, see p. 190)

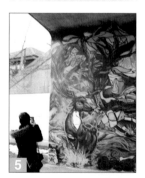

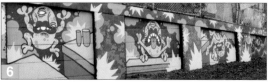

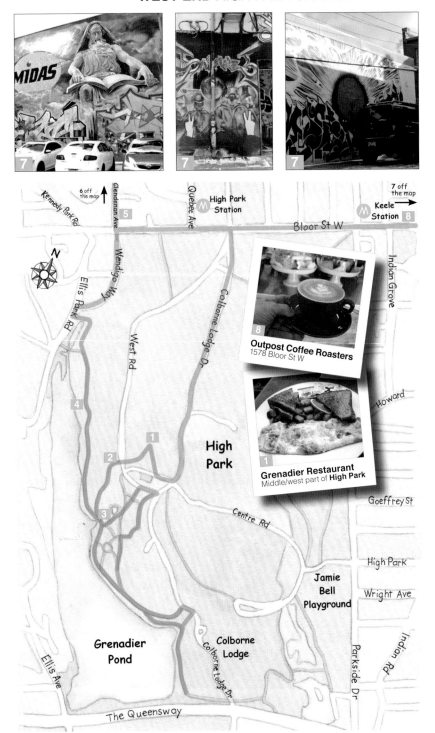

Kennedy Park Rd

Glendonan Ave

5

Quebec Ave

High Park
Station

Keele
Station

8

Bloor St W

N

Wendigo Way

Ellis Park Rd

West Rd

Colborne Lodge Dr

Indian Grove

Outpost Coffee Roasters
1578 Bloor St W

8

Howard

4

1

2

3

High
Park

Grenadier Restaurant
Middle/west part of **High Park**

Centre Rd

Goeffrey St

High Park

Jamie
Bell
Playground

Wright Ave

Grenadier
Pond

Colborne
Lodge

Colborne Lodge Dr

Parkside Dr

Indian Rd

Ellis Ave

The Queensway

STROLL 41

Neighbourhood
Junction Triangle

Suggested walk
7.5 km (1 hr 50 min)

1 **Café Neon**
2 Around track on Wallace
3 **West Toronto Railpath**
4 Railpath north of Dupont
5 S side of Bloor Underpass
(About **artists**, see p. 190)

On the map, you can see the triangle formed by the junction of three railways running through Dupont, Bloor and Dundas. For street artists, urban railways mean underpasses! Lots of them! Add to this the fun of strolling along the **West Toronto Railpath** and to see one of Toronto's best art installations on Lansdowne.

TTC & Parking
• Exit at **Lansdowne** or **Dundas West Subway Stations**.
• There's free street parking along Wallace Ave and nearby streets.

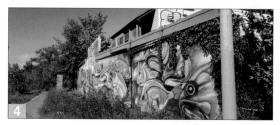

While you're here
• **Jellyfish Emporium** is a fun collective of vintage vendors of clothing, accessories, toys and gadgets.
• Follow lane in back of **Caldense Bakery** (337 Symington) to access **Boulderz Climbing Centre**.

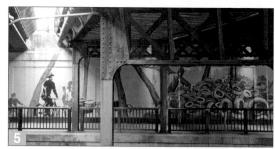

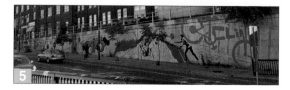

Café Neon
241 Wallace Ave

Dolly's
1285 Bloor St W

Hula Girl Espresso Boutique
2473 Dundas St W

Hale Coffee Company
300 Campbell Ave #103

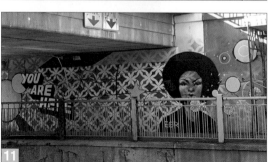

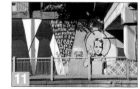

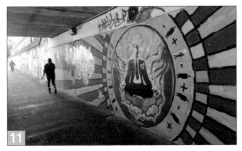

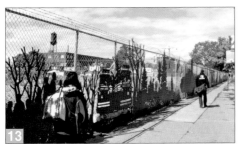

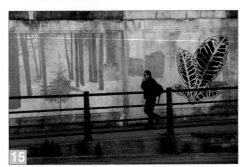

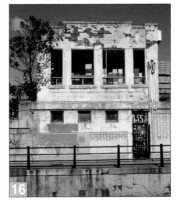

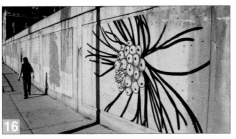

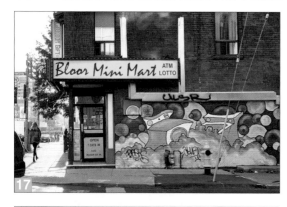

17 Bloor W & Symington
18 Bloor Underpass
19 Railpath S of Bloor W
20 Railpath S of Bloor W
21 Southern end of Railpath
22 Railpath S of Bloor W
23 Pedestrian bridge between Dundas W and Wallace
24 **Hula Girl**
25 Lane S of Glenlake Ave
(About **artists**, see p. 190)

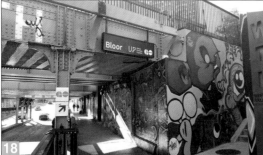

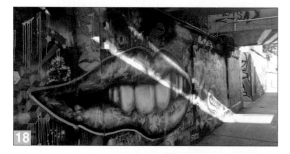

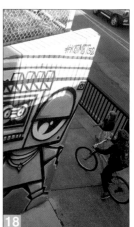

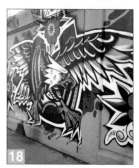

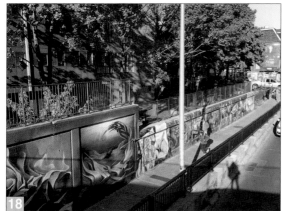

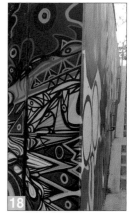

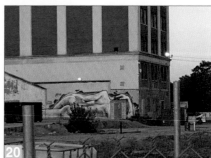

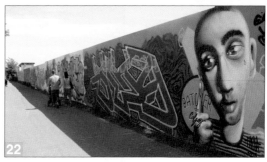

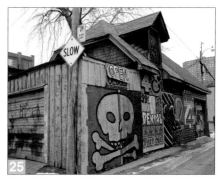

STROLL
42

Neighbourhood
Roncesvalles Village + Parkdale

Suggested walk
5 km (1 hr 15 min)

This stroll with Old-Europe vibes explores the most interesting grid of back lanes (including two clusters of street art on each end).

TTC & Parking
• **Dundas West Subway Station** is a 6-min walk north of Roncesvalles & Dundas West.
• Streetcar **504** runs along Roncesvalles.
• Plenty of free street parking after 10 am east of Roncesvalles.

While you're here
• At the time of print, the live music venue/restaurant **Hugh's Room** (2261 Dundas W, off the map, **www.hughsroom.com**) was on the verge of re-opening as a not-for-profit in order to survive!
• The **Revue** (400 Roncesvalles, **www.revuecinema.ca**) is an independent cinema.
• You can access the waterfront from a pedestrian bridge at the foot of Roncesvalles.

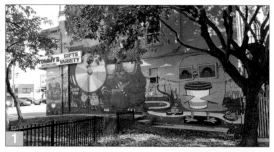

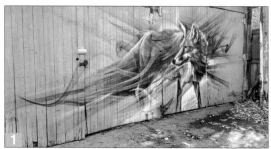

1 W side of **Tommy's**, in park and in lane S of playground
2 **Suitcase**
3 Lane N of Columbus Ave
4 **Belljar Café**
(About **artists**, see p. 190)

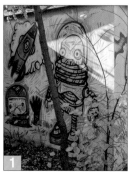

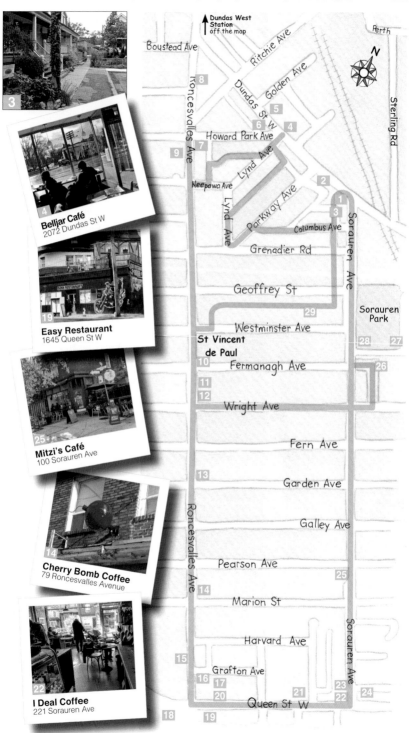

Boustead Ave

Ritchie Ave

Golden Ave

Perth

Dundas West
Station
off the map

Sterling Rd

8

Dundas St W

5

6

4

Howard Park Ave

7

9

Lynd Ave

Roncesvalles Ave

Neepawa Ave

Lynd Ave

2

Parkway Ave

1

3

Columbus Ave

Sorauren Ave

Grenadier Rd

Geoffrey St

29

Sorauren
Park

Westminster Ave

28 27

St Vincent
de Paul

10

Fermanagh Ave

26

11

12

Wright Ave

13

Fern Ave

Garden Ave

Galley Ave

Pearson Ave

25

14

Marion St

Roncesvalles Ave

Harvard Ave

Sorauren Ave

15

Grafton Ave

16 17

23 22

21

24

20

Queen St W

18

19

Belljar Café
2072 Dundas St W

Easy Restaurant
1645 Queen St W

Mitzi's Café
100 Sorauren Ave

Cherry Bomb Coffee
79 Roncesvalles Avenue

I Deal Coffee
221 Sorauren Ave

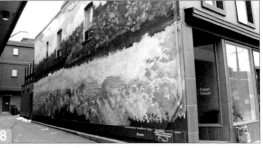

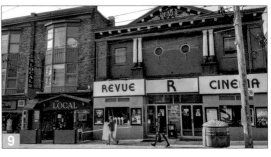

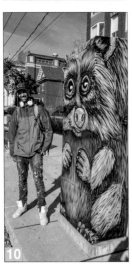

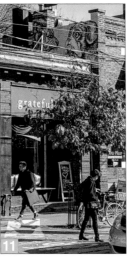

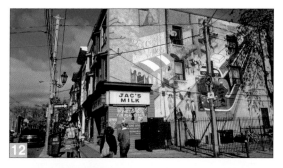

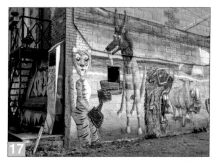

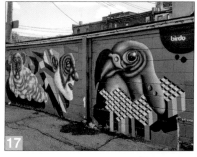

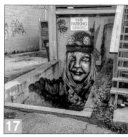

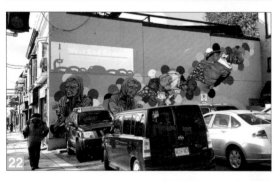

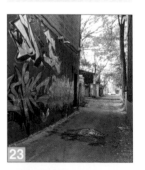

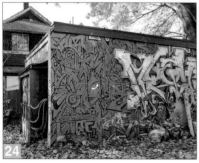

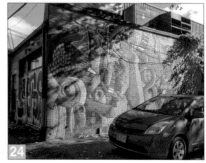

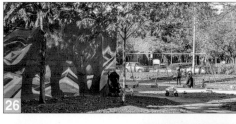

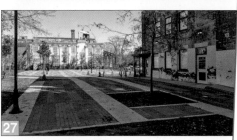

THE TAO OF STREET ART
Think win-win

I came upon **Jeff Blackburn** by chance as he was putting the last coat of varnish on a traffic light box off Roncesvalles, a commission he got from **StART** (more about it on p. 33). I had just admired his giant raccoon in the little park at Sorauren and Dundas West, and told him so. "There's also the one right there!" said he, pointing to a mural which I had missed on top of the eastern buildings. That one was a private commission from people who live in the apartment across from the mural! They got permission from the owner to put art on the sidewall of his building. Blackburn got paid. His client gained a fun view. The building looks better. And we all get to enjoy more whimsy in **Roncesvalles Village.** What a great win-win model to emulate!

We become cool creators when talking the time to find the advantage for all involved in a situation.

STROLL
43

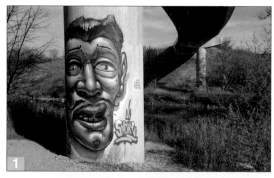

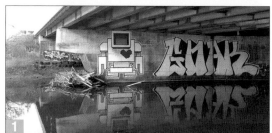

Neighbourhood
Weston

Suggested walk
3.3 km (50 min)

This is a good example of the **Toronto 2015 Pan Am** legacy. While a large collective of artists worked under the 401, the beautiful mural under **St. Phillips Bridge** (accessible from **Mallaby Park**) was done by **Dan Bergeron**, **Emanuel Ciobanica** and **Gabriel S**.

TTC & Parking
• Bus **73** runs along Weston Rd.
• There are free parking lots In **Pine Point Park** (at the foot of Allenby Ave) and in **Crawford Jones Memorial Park** (at the foot of Dee Ave).

While you're here
• From **Mallaby Park**, you can access **Humber River Recreational Trail** bordering **Humber River**. If you walked for 9.3 km, it would take you to **Étienne Brulé Park**.

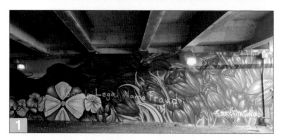

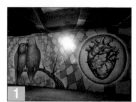

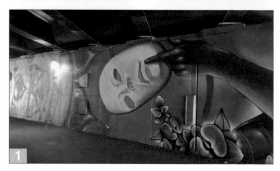

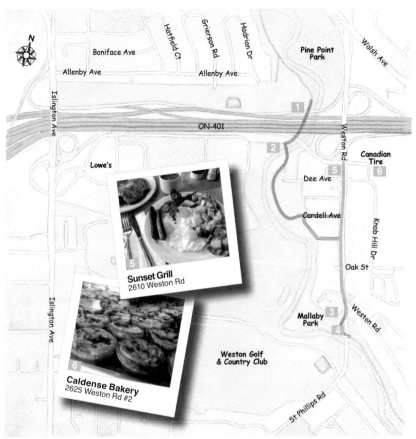

Sunset Grill
2610 Weston Rd

Caldense Bakery
2625 Weston Rd #2

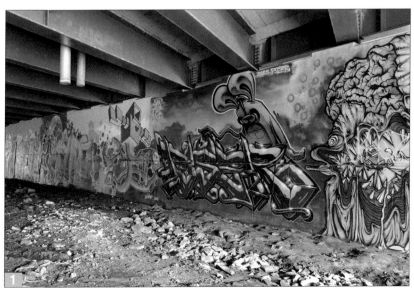

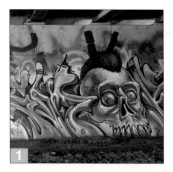

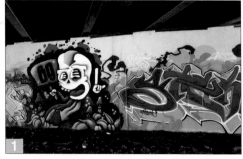

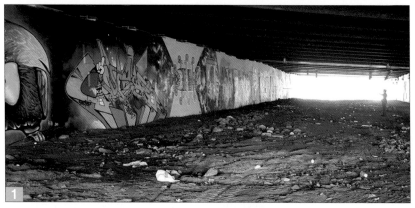

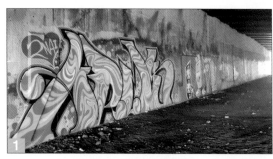

1 Under the 401
(two tunnels to explore)
2 Pedestrian bridge over
Humber River
3 **Mallaby Park**
4 Under St Phillips Bridge
5 **Sunset Grill**
6 **Caldense Bakery**
(About **artists**, see p. 190)

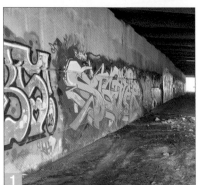

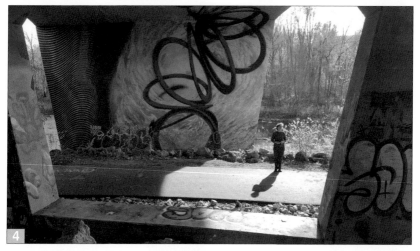

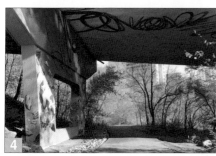

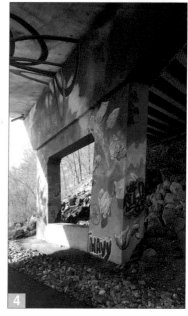

About the PERCENT for PUBLIC ART program

Since 2010, Toronto has followed the great example of other big cities.

The City has adopted the program which requires developers to make public art contributions (on-site or off-site), based on one percent of the gross construction cost of the development project. It's thanks to this program that we can now admire so many large pieces of public art around condos and major buildings. The **City Place Stroll** best illustrates the advantage of such a program.

You can access an interactive map of all the public art in Toronto when searching *Percent for Public Art* on **www1.toronto.ca**.

Art by **Tadashi Kawabata** on Front St E (Stroll 16)

ARTSY EVENTS

& GETAWAYS

Bring toonies!

The BuskerFest used to be on Front, then on Yonge. Now, it has set tent in Woodbine Park, with plenty of room to circulate and enjoy the different interactive acts. In past festivals, my son has been held hostage by menacing gladiators, was involved in a balloon sculpture contest, has shaken hands with an extraterrestrial and has passed the hat for a wacky cowgirl.

Buskers from different cultures rival to entertain us. It is quite interesting to see how humour differs from one country to the next.

Over the years, I have noticed that Australians are the most provocative, UK performers play with the absurd, Americans are more politically correct and Canadians have a tendency to downplay their act to better surprise us with something bold when we're off guard.

Bring lots of toonies to hand over when the artists pass the hat at the end of their shows! It's part of the game.

Toronto International BuskerFest for Epilepsy
(15 min from CN Tower)
www.torontobuskerfest.com

Admission
Donation for Epilepsy Toronto at the door and artists pass the hat.

Schedule
2017: September 1-4
Friday, noon to 11 pm
Sat., 11 am to 11 pm
Sun., 11 am to 10 pm
Mon., 11 am to 8 pm
(usually on Labour Day weekend).

You are here!
Woodbine Park,1590 Lake Shore Blvd E at Coxwell, Toronto.

While you're here
• Lots of food options on the premises.
• **Woodbine Beach** is across the street.

Sleepless in TO

It's very hard to predict what awaits you at any of the installations during Nuit Blanche. The activities can last anywhere from 2 minutes to half an hour. There can be a massive crowd attending, or hardly anyone. The unknown is actually part of the fun. Control freaks will want to avoid this experience.

Now that Scotiabank is not involved anymore with the event, it is less ambitious, but you can always expect a pièce de résistance at **Nathan Phillips Square**. In 2016, we were treated with a trippy projection on a gigantic sphere in the middle of the square. The little street behind City Hall was lined with books which we could take.

In previous years, we've seen immense clown heads peek through the buildings. We've visited a chapel entirely made out of camping gear. We've walked underneath garlands of little socks...

Nuit Blanche
(all over Toronto)
311 (Access Toronto)
www.nbto.com

Admission
FREE

Schedule
2017: Saturday, September 30 from sunset to sunrise (usually last Saturday of September).

You are here!
Nathan Phillips Square is the heart of the event (at Queen & Bay) but go to **Nuit Blanche** website for the other locations.

While you're here
• There are food trucks all around town and many restaurants and cafés open late.
• Go up **City Hall**'s ramp to check the rooftop!

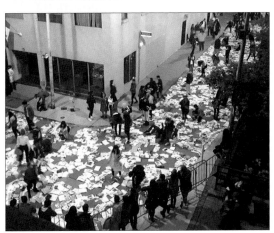

FEBRUARY BLOOR-YORKVILLE ICEFEST

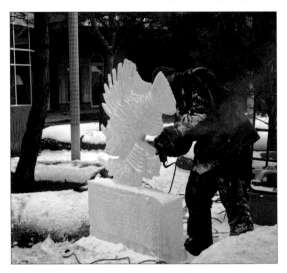

Event on the rocks

Every year brings a new theme to **Icefest**, a tradition since 2006.

For the occasion, Cumberland Street goes carless from Bellair to Old York Lane. It gets quite festive around the pretty **Village of Yorkville Park**, with an ice carving competition (usually starting at 12 noon on Saturday), a couple of ice bars, and ice carving demonstrations.

It is fun to watch artists attack a block of ice, armed with a chainsaw... or a curling iron! The sculpture gets covered in white dust in the process but it will end up crystal clear.

Usually, with a $2 donation, on Saturday and Sunday at 2 pm, you can get an ice square cut from a larger block, encasing a toy car. You can also taste yummy maple syrup taffy on the snow. The money collected through this cool fundraising activity goes to the **Heart & Stroke Foundation**.

The ice sculptures are nicely lit at night. Weather permitting, they can last as long as a couple of weeks after Icefest.

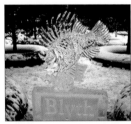

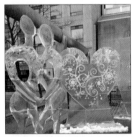

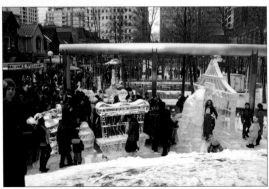

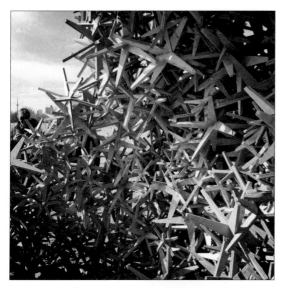

Art by the beach

This event took the locals by surprise in 2015! Word-of-mouth caught on fast about the weird installations being erected around the lifeguard stations.

Now, we can't wait to find out what clever way the designers will come up with to reinvent the stations. The results are unique whimsical microcosms to explore, allowing us to view the lake from a different angle. Some are meditative, others more interactive.

Winter Stations is an international design competition open to anyone, amateur or professional. (Winners receive $10,000 for construction and $3,500 for design. The deadline to apply is early November.)

This competition is a wonderful opportunity to find out that glistening water under the sun and gentle waves rolling onto the beach are as good for the soul at minus 10 as they are in the summer. It is also much easier to find free street parking in the winter!

Winter Stations also partnered with the **Waterfront BIA** to present *Icebreaker* installations in February 2016. Let's hope this becomes a tradition!

Winter Stations Design Competition
(15 min from CN Tower)
www.winterstations.com

Admission
FREE

Schedule
Usually from the last week of February to the last weekend of March.

You are here!
The stations are located along **Woodbine Beach**, **Kew Beach** and **Balmy Beach** (on both sides of the dog park).

While you're here
• Stop for honey balls at **Athens Pastries**, just north of Woodbine Beach!
• **Beach Cinemas** is a 10-min walk from Woodbine Beach.

GETAWAY

KLEINBURG SCULPTURE GARDEN

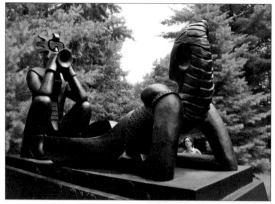

McMichael's Sculpture Garden

• **Kleinburg**
(45 min from CN Tower)
(905) 893-1121
**www.mcmichael.
com**

Admission
FREE to visit the garden ($5 for parking).

Schedule
Open daily, May1 to Oct. 31, 10 am to 5 pm (closed on Mondays and at 4 pm the rest of the year).

You are here!
Located on **McMichael Canadian Art Collection** premises, 10365 Islington Ave, Kleinburg. From Hwy 400, take exit #35/ Major MacKenzie Dr westbound, then turn north on Islington.

While you're here
• See the Group of Seven masterpieces inside the gorgeous **McMichael** Gallery.
• Their restaurant has a lovely patio.

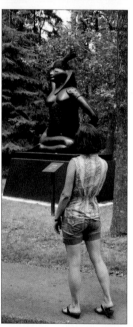

Outdoor gallery
The **Sculpture Garden** features nine impressive artworks donated by the artist **Yvan Eyre**, a painter and sculptor who was appointed a member of the Order of Canada in 2015 in recognition of his significant contribution to art in Canada.

The sinuous loop trail is a short walk from the parking lot. It takes no more than 10 minutes to complete and it is perfect at generating anticipation. You keep wondering what lies around the next corner.

On a sunny day, the dark bronze sturdy characters (each weighing between 2,000 and 4,000 lbs) contrast nicely against the tender green background of leafy trees. Each one is mysterious in its own way.

Til death...
The Sculpture Garden sits across from the **Group of Seven** cemetery where you will find natural stones bearing plates with the names of the gallery co-founders **Robert** and **Signe Mc-Michael** along with those of six of the ten members of the Group of Seven and their spouses.

One would assume that the little graveyard is a memorial, but it is indeed the resting place of Lismer, Varley, Harris, Johnston, Casson and Jackson... and the Mc-Michael couple. They truly were art lovers until the end!

There's more

You will need to pay the $5 parking fee at the gate but you don't have to pay admission to the gallery to access the Sculpture Garden and enjoy the surroundings.

You can peek inside Tom Thomson's shack (which was moved here from its original location). You can admire the carved boulders and the guarding wolves near the main building.

And while you're at it, enter the gallery's lobby to observe the totem with a modern twist... You will need to have a close-up look to see what I mean!

The trails are pretty in the spring and the summer and even better during the fall. If you keep your right on the path in the back of the gallery, the **Humber River Trail** will lead you, in 1.5 km, to Major MacKenzie Drive.

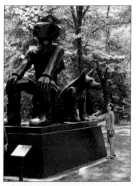

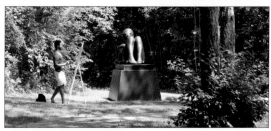

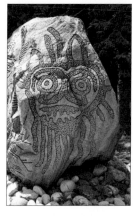

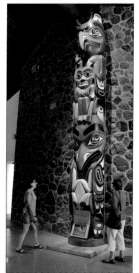

Art Walk of Tree Sculptures

• **Orangeville**
(60 min from Toronto)
(519) 941-0440
www.orangeville.ca

Admission
FREE

Schedule
Open year-round

You are here!
Starting point at Broadway & First Street, Orangeville. Print their map! Take Hwy 410 northbound, it becomes Hwy 10. Turn west at the lights on Hwy 10 to access Broadway, which runs through Old Orangeville.

While you're here
• The commercial intersection at Broadway and First St includes funky art shop **Dragonfly Arts on Broadway** (189 Broadway) and cute cafés and restaurants such as **Mochaberry** and **Pia's on Broadway** (177 Broadway).

Download the map!
Instead of getting rid of its dead tree stumps in 2003, Orangeville decided to ask sculptors to make something out of them. And they did. You hear that, Toronto?

You can download the **Art Walk of Tree Sculptures** brochure from Orangeville's website. The walk now includes 58 tree sculptures, the artwork of 19 carvers.

The sculptures are spread over a vast area so you could easily miss most of them without the map.

Broadway & First St
Try to park near the intersection of the lovely main street Broadway and First Street. You will see most of the sculptures along these two streets.

When I visited, we started by going northbound on First Street. We could see it stretching a long way in front of us. That's where we found *The Hunter*, allowing us to stand inside a silhouette carved into the trunk.

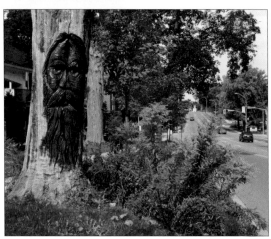

Turning left on McCarthy Street, we befriended a moose. We turned left again on Faulkner to reach Zina Street (a truly beautiful street with splendid houses). Going right on Zina, we turned on Louisa Street, which took us back to Broadway.

South of Broadway, the cute *Hobbit House* caught our attention at 30 Margaret Street.

Jim Menken, whose *Woodland Creatures and Horses* and *German Sheppard* can be found in the **Greenwood Cemetery** (a 20-min. walk going westbound on Broadway), is the sculptor who carved the racoon on the stump in **Riverdale West Park**! **Colin Partridge**, who carved many *Tree Spirits*, also did four spirits that can be found in **High Park**.

Fall colours

This is a cool destination in the fall to admire the fall colours around **Belfountain** (a 20-min. drive going south on the way back to Toronto).

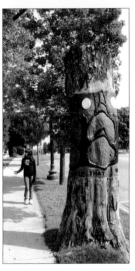

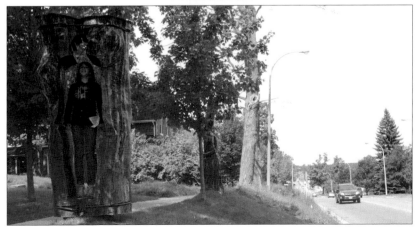

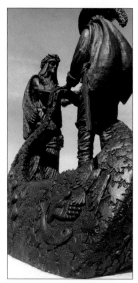

The Meeting

You can thank Samuel de Champlain for the metamorphosis that turned Rotary Park into a world-class attraction.

Rotary Champlain Wendat Park was created to commemorate Champlain's visit in 1615. It is said that he landed 400 years ago on the exact spot near the pier where a canoe sculpture has been installed, the beginning of 400 years of French presence in Ontario.

The beautiful bronze statue overlooking the harbour depicts Champlain's meeting with Chief Aenons of the Huron Bear Tribe. *The Meeting* (by artist **Timothy Schmalz**) sits next to a great lookout that feels like a large moored ship.

Leaving a legacy

Turning around, you'll see the **Legacy Walkway**, with **St. Ann's Church** in the background. It features more of the intricate art by Schmalz: six statues portraying individuals and nations who have played a major role in the Francophone history of Ontario.

PENETANGUISHENE SCULPTURE PARK

You can read the story of Champlain's passage through Ontario in 1615, told in English, French, Anishinabe, Montagnais-Innu, Mohawk, and Wendat on three plaques by the walkway.

More art

At the end of the walkway, make sure to look through the looking glass held by life-size John Simcoe!

The statue is the work of **Tyler Fauvette**, who also did the four reliefs in a circle a bit further into the park, bronzes mounted on Georgian Bay granite representing core members of the Wendat Confederation People of the Bear, Cod, Deer and Rock.

Along the 2.5 km **Trans-Canada Trail** which runs through the park, you'll find a giant astrolabe (the astronomical instrument used by Champlain to navigate), a lovely playground with a nautical theme, and an outdoor amphitheatre.

Awenda Provincial Park (with superb camp sites) is a 15-min drive from the park.

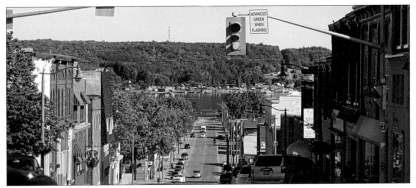

The journey

This attraction is lovely at any time of the year but if you're looking for a destination to admire fall colours, this is it! In the fall, **Haliburton Sculpture Forest** is the perfect excuse to call friends and plan a road trip. It doesn't matter if you can't stay overnight in Haliburton. As the saying goes, the journey is as important as the destination.

I suggest you leave early with friends. Enjoy the view until you reach Haliburton. Have a bite at **Kosy Korner**, check out one of Ontario's best fall panoramas from **Skyline Park**. Then visit the **Sculpture Forest** (an 8-min drive) before returning home, your head filled with art and colours.

Haliburton Sculpture Forest
(2 hrs 30 from Toronto)
(705) 457-3555
**www.haliburton
sculptureforest.ca**

Admission
FREE

Schedule
Open year-round

You are here!
The parking lot at **Haliburton Museum** is near the entrance to the forest (66 Museum Drive, Haliburton). Stay on County Rd 21 running through Haliburton (as Highland St) and turn left on Maple Ave to drive around Head Lake. Turn left on Bayshore Rd, which becomes Museum Dr.

The destination

Launched in 2001, the outdoor gallery now includes 27 sculptures and 3 artsy benches set in a gorgeous forest around **Haliburton School of the Arts**. You can download the trail map from their website for location and artist information.

While you're here
• **Kosy Korner** diner (166 Highland St) has been around since 1935! **Skyline Park** is a 4-min drive away. From Highland St, take Maple St to Mountain St (ON-118), turn right at sign.

Don't miss **John Mc-Kinnon**'s wonderful *Atmo-Sphere*, offering a secret sunlit sanctuary. He's also the one responsible for the beautiful flock of crows in flight.

You can visit the modern art school. See the blue horse sculpture by **Bill Lishman** by the entrance? He did the colourful sculptures around **Bridgepoint Health Centre** (see p. 90). I also enjoyed the nice little **Haliburton Highlands Museum** on the premises.

No GPS?

Going northbound on Hwy 404, turn left at RR 8 (Woodbine Ave). It's lovely country roads from then on, following RR 32 East (Ravenshoe Rd), ON-48 North, RR 12 North, ON-48 (Durham) and ON-35 North. You will pass by **Miner's Bay Lodge** (9718 ON-35 N), a quaint cottage rental place frozen in time! Turn right on R 21, past **Kawartha Dairy** in Minden (a perfect stop for ice-cream at 12750 Hwy 35). R 21 becomes Highland St in Haliburton.

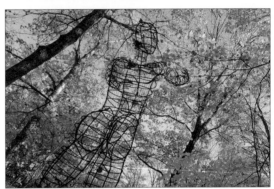

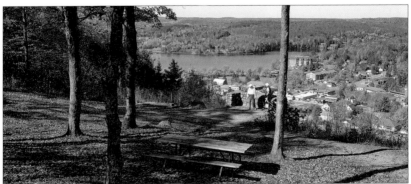

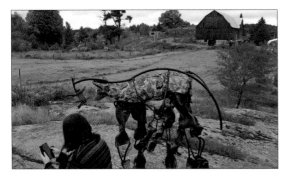

Godfrey Sculpture Park
(3 hrs from Toronto)
www.duerst.ca

Admission
FREE (donation accepted)

Schedule
Open daily, May 1 to Oct. 30, 9 am to 5 pm.

You are here!
Located at 79 Buck Bay Rd, Godfrey. From the 401, take Exit #611 northbound (Hwy 38/Gardiners Rd), turn right at Westport Rd, then left at Buck Bay Rd.

While you're here
• Stop on the way at yummy **Food Less Travelled** in Verona!
• At south/east corner of Hyw 38 and Westport Rd), **Godfrey Social Club** serves coffee and all-day breakfast (pool table).
• Westport Road eastbound is very pretty and leads in 20 min to quaint **Village of Westport**, a cool place for B&Bs.

North of Kingston
I came upon **Godfrey Sculpture Park** by chance, seeing the signs on my way to my friends' farm, north of Kingston. Didn't know what to expect. Wow!

Field path
Sculptor **Stefan Duerst** has created a lovely walk through the field behind the barns, turning his 60-acre property into a bucolic modern art gallery.

Most of his sculptures on display are for sale (many fetching over $10,000). Here and there, we find little notes on empty spots saying: "I found a new home".

Forest trail
The loop offers a 20-min walk but you can take a short (and well-marked) side trail at the turning point, adding 30 minutes to your walk.

It leads into the Precambrian forest where the trail serpentines around gorgeous rock plateaux (to admire the valley) and giant old trees bordering a beaver pond. (We saw the beavers! And the view over the valley is superb.)

Look carefully for more art winks by Duerst peppered along the trail.

Street art connection

When I visited for the first time, Stefan Duerst was working on a piece in his studio near the starting point of the sculpture trail.

By pure happenstance, while chatting with him, I learned that he was soon expecting the visit of **Loomit**, German graffiti artist legend, to work on a duo exhibition! **Bert (Nils)**, another famous German street artist, was part of the adventure.

When I returned the following month, they had left a large mural on the side of the big barn, as a souvenir of this international collaboration in the heart of Godfrey!

Duerst art in Toronto

Duerst has worked for over 20 years with clients, engineers, architects, developers and landscape designers.

You can see some of his art inside **Bridgepoint Health Centre** in Toronto (see p. 90-91).

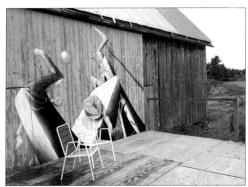

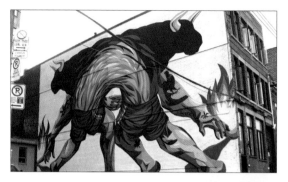

The festival

The **MURAL** international festival of public art was born in 2013. The 11-day interactive festival takes place in June, in and around Saint-Laurent Boulevard. Each year, it adds to MURAL's current flamboyant circuit of murals, which we can admire year-round.

There are now over 60 large murals around Montreal, with a cluster of urban gems around Saint-Laurent Boulevard.

It can happen that old murals are covered by new ones but MURAL producers haven't hit the wall yet. They have identified over 200 walls suitable for murals.

Montreal MURAL
(6 hrs from Toronto)
www.muralfestival. com

Admission
FREE

Schedule
See the murals all year-round. **MURAL** festival takes place in June over 11 days.

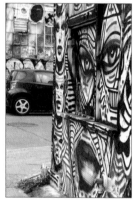

Wall-to-wall murals

The MURAL's interactive maps on their website are better enjoyed on smartphones as you stroll Saint-Laurent. They point out the murals by year of creation, with artist names.

You can see many artworks as you walk along Saint-Laurent Boulevard but many more are hidden left and right off the Boulevard, from Sherbrooke to Mont-Royal, 1.5 km further north.

You are here!
Murals are all around downtown Montreal, from the **Quartier des spectacles** (around **Place des arts**) to the **Mile End** (north of Mont-Royal), but mostly around Saint-Laurent Boulevard. Check the maps on their website.

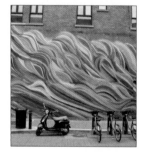

While you're here
• Check the **Quartier des spectacles**' special light effects by night (175 Sainte-Catherine St West).
• Visit **www.montrealenhistoire.com** to learn about the fantastic multimedia tableaux projected at night on walls, ground and trees in Old Montreal!

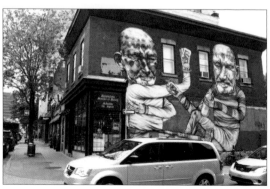

W of Saint-Laurent

The mural on the side wall of **Café Nocturne** (19 Prince-Arthur St W) is an example of the way some murals hide from us. If you keep walking northbound on Clark, between Prince-Arthur and Mont-Royal, you'll see more, well worth the detour.

In that area is the hidden garden of funky **Café Santropol** (3990 Saint-Urbain St off Duluth) serving triple decker sandwiches, ambitious shakes and raw desserts.

E of Saint-Laurent

Parc du Portugal sits at Saint-Laurent & Marie-Anne (look for **Bryan Beyung**'s *Toreador*). **Leonard Cohen** lived on Vallières St just south of this park!

Lots of cool art is to be seen around Saint-Dominique at Marie-Anne and at Napoléon St And the whole of Duluth Ave, up to Châteaubriand, east of Saint-Denis, is simply lovely!

Afghan food is on the menu in the gypsy backyard of **Khyber Pass** (506 Duluth E) and generous Greek servings in the superb Mediterranean courtyard of **Jardin de Panos** across the street.

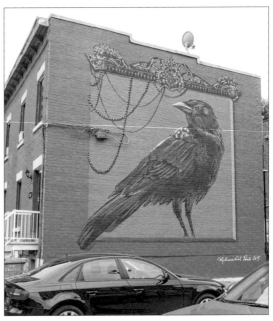

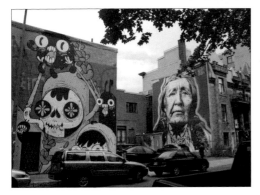
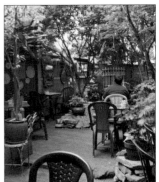

ALPHABETICAL INDEX

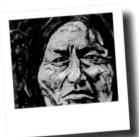

ALPHABETICAL INDEX

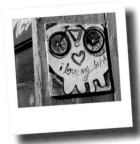

ALPHABETICAL INDEX

NEIGHBOURHOODS

Turning Toronto into an outdoor gallery, one alley at a time...

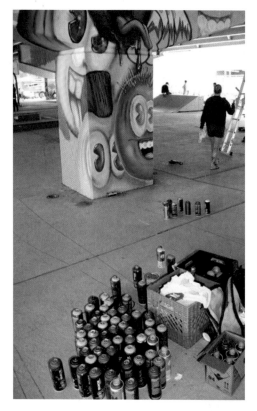

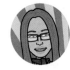

Contact Nathalie Prézeau:
Text: 416-462-0670
torontofunplaces@gmail.com
facebook.com/TorontoUrbanStrolls
@torontourbanstrolls (Instagram)

I had a dream...

When I started this book project, I planned for it to include the name of every artist involved, with the exact location of their artwork.

It turned out to be more difficult than I expected. While the big murals and larger pieces are usually clearly signed, many are anonymous or carry a tag which seems less like a signature and more like an inside joke for the benefit of the graffiti community. I haven't cracked the code yet, but at least I know that I don't know!

In addition, when an artist collective works on a wall, it can involve from 3 to 30+ street artists. There's also the fact that some artists prefer to remain anonymous.

Change of plans

I've decided instead to create a **Street Artists** section on my website **www.torontofunplaces.com**. It will be a work-in-progress over the coming year, featuring artist pages with references to the guide *Toronto Street Art Strolls* and all the links they would like me to publish to promote their work and allow potential clients to reach them for commissions.

Wouldn't it be great if all the Toronto owners of ugly garage doors hired an artist to embellish their back alley? The city would soon be peppered with outdoor art galleries promoting neighbourhood walks.

Call for street artists

I invite the artists featured in this guide to contact me so I can create a courtesy page for them on my site, to show my appreciation for everything they do to inject life into the grey corners of our city.

About StreetARToronto
A pro-active program launched in 2012 by the City of Toronto.

Also called **StART**, it aims to develop, support, promote, and increase awareness of street art and its indispensable role in adding character to neighbourhoods and revitalizing public spaces across Toronto, while counteracting graffiti vandalism. They are responsible for the three programs **StART Partnership** (for large-scale projects), **Support's Mural** (for private property owners), and **Outside the Box** (for art on traffic light boxes). Not to be confused with the **Bell Box Murals Project** (for art on Bell utility boxes). This collaboration between private enterprises, community arts organizations and many other partners was launched in 2009.

Search *streetart* on **www1.toronto.ca** to access the **Artists Directory** including the profil of over 130 street artists.

Art by **Jeff Blackburn** on Queen St W (Stroll 4)

AUTHOR'S **CHEAT SHEET**

Suggestions to help you choose a walk!

Mad for murals? You can spot fantastic murals all over town but some neighbourhoods have chosen to invest in murals to acquire a unique character.
TOP-3 strolls for mural lovers: **5, 26, 39**

Crazy for graffiti? Once you've seen the popular Rush Lane (Stroll 8) and eclectic Kensington Market (Stroll 12), where else can you satisfy your passion?
TOP-3 strolls for graffiti fans: **11, 15, 30**

Wild about public art? Many beautiful master-pieces are hidden in courtyards. Others are located on condo turf. Not your first choice for a walk? You won't be disappointed with the following.
TOP-3 strolls for public art dilettantes: **6, 9, 16**

Having guests over? Leave this guide in their room for inspiration. If you have to work while they're visit-ing, they will be able to use the self-guided walks to explore the city by themselves.
TOP-3 strolls for tourists: **2, 10, 15**

Looking for outings for teens? Hand them the guide with pocket money for snack and beverages. They'll figure out the rest, and will Snapchat all the way.
TOP-3 strolls for teens: **8, 12, 30**

Walking with kids? These strolls include fun play-grounds, the perfect incentive to motivate the kids to walk without even realizing it. You're welcome.
TOP-3 strolls for little walkers: **2, 13, 16**

Care to explore cool cafés? Most strolls include a decent coffee shop (usually featured in the Polaroid pictures near the map). Some offer more options!
TOP-3 strolls for caffeine fix: **15, 22, 39**

Need to reconnect with nature? Some of the best street art is found near great parks with long walking paths! Best places for great conversation.
TOP-3 strolls for nature walks: **23, 29, 43**

Want to discover Toronto differently? Explore Toronto's cutest streets, most exotic area and best cityscape (and spot to watch the sunset).
TOP-3 strolls to be surprised: **3, 19, 21**

Are you a night owl? Some strolls look beautiful at night when the lights come on, offering a very differ-ent experience from what you see in daylight.
TOP-3 strolls for evening walks: **6, 10, 16**

Looking for art extremes? Check these exciting walks off your bucket list.
TOP-3 must-see strolls: **8** (longest & oldest graffiti alley), **14** (tallest mural, as seen on this page), and **33** (longest & most beautiful mural).